IMAGES
of America
LONGVIEW

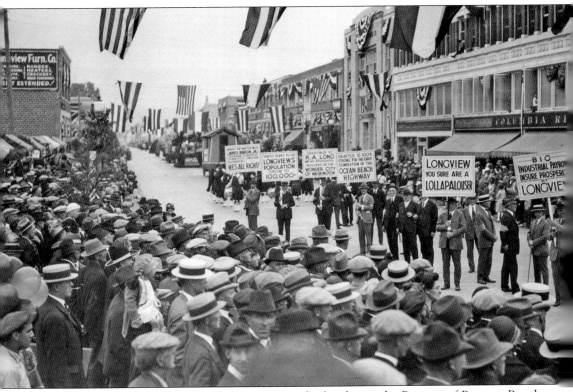

Hopes and dreams of founding fathers were on display during the Pageant of Progress Parade, celebrating Longview's first anniversary in July 1924, as celebrants lined the main downtown street, Commerce Avenue. (Courtesy of Cowlitz County Historical Museum.)

ON THE COVER: With beautiful trees lining the Longview neighborhood's street and providing homes for squirrels, young and old alike decided to inspire local business leaders to build the world famous Nutty Narrows Bridge, giving squirrels safe passage over the busy thoroughfare and building up civic pride. (Courtesy of the Sandbagger Collection, Cowlitz County Historical Museum.)

IMAGES
of America

LONGVIEW

Dennis P. Weber with
Karen Dennis and Sue Maxey

ARCADIA
PUBLISHING

Published by Arcadia Publishing
Charleston, South Carolina

Printed in the United States of America

Library of Congress Control Number: 2012940644

For all general information, please contact Arcadia Publishing:
Telephone 843-853-2070
Fax 843-853-0044
E-mail sales@arcadiapublishing.com
For customer service and orders:
Toll-Free 1-888-313-2665

Visit us on the Internet at www.arcadiapublishing.com

This book is dedicated to our families, who "loaned" us for this project; to our parents, who gave us the intellectual curiosity to seek the real stories behind the pictures; and to the '23 Club who has never let the vision go out.

CONTENTS

ACKNOWLEDGMENTS

Our sincere thanks go to the following: the volunteers at the Cowlitz County Historical Museum, who always greeted us with warm smiles; our Arcadia Publishing editors, especially our original editor, Coleen Balent, whose limitless patience kept the project on track; office manager Jim Elliott of the Cowlitz County Historical Museum, the one with the key to unlocking digital files; Bill Watson, curator at the Cowlitz County Historical Museum, whose focus and discipline is making more and more images available every week; museum director David Freece, a fountain of suggestions, puns, and encouragement; Longview Public Library librarian Chris Skaugset and his entire staff for their support; executive staff of the City of Longview for their assistance; Tony and Kim Fardell for donating the photography collection of their father, Jan Fardell, to the historical society; and friends Lloyd Smith, Tom Gunn, Wendell Kirkpatrick, Linda Monahan, Brenda Nanney, and Joan Wilcox, who were willing to share personal photographs and memories. Without all of you, none of this would have been possible!

INTRODUCTION

At his command post in a downtown Kansas City skyscraper, the nation's foremost lumberman R.A. Long received the devastating report from his company's timber scouts in 1918: his sources for raw material were nearly exhausted. The American economic boom fueled by a brutal war in Europe had enriched him beyond anything he ever imagined as a Kentucky farm youth. But the once-lush forests of the Mississippi Delta had been converted into farmland. Now, his Long-Bell Lumber Company was at a crossroads.

The 68-year-old timber baron put the question to a vote by his board of directors: disband or build the world's largest lumber mill elsewhere? This group of middle-aged men looked upon "Mr. Long" as a father figure and a proverbial King Midas, able to turn wood into gold. Their decision was easy: they wholeheartedly endorsed the plan to build. And their vision became the Longview story, combining innovation, a healthy dose of old-fashioned paternalism, and a whole lot of money into a 20th-century urban success story.

A search for the best timberlands commenced, and once found, the company's engineer developed an action plan as he researched the ideal location for the mill site. Veteran timber cruiser William F. "Uncle Bill" Ryder traveled from Northern California to the Olympic Peninsula before recommending timber in southwest Washington. Long-Bell chief engineer Wesley Vandercook then focused on Pacific Northwest geography and labor markets, penning a 120-page tome extolling the virtues of the Columbia River as the key to success.

Ryder recommended massive old-growth stands of Douglas fir and Western hemlock, with logs so thick that a modest family home could be built from just one! An estimated total of six billion board feet was purchased from Weyerhaeuser Timber Company for $14 million. The center of logging operations eventually came to be known as Ryderwood.

Vandercook's report set the stage for a grander vision. His investigation of wild, radical Northwest loggers and lumbermen led him to declare that Long-Bell's best chance for a reliable workforce was to construct a family-oriented city. The ideal location for Long-Bell's western headquarters, he concluded, was the floodplain at the mouth of the Cowlitz River in the Lower Columbia Valley, with easy access to transcontinental railroads and ocean-going steamships.

The Columbia had long served as a vital corridor of commerce for native tribes in the region. With an abundance of salmon for food, grasses and bark for baskets, and cedar for canoes, the Chinookan-speaking Cathlamet and Skilloot tribes traversed as far upstream as The Dalles with surplus goods, including slaves, building strong relationships through trade and intermarriage.

Rising from the foggy mists of the swampy Cowlitz Delta was a dramatic igneous plug where local tribes laid their deceased relatives in canoes, wrapped in blankets with precious treasures and precariously perched on its rocky slope. Early British and American explorers noted this "Mount Coffin" during their journeys through the Columbia River valley. Later, pioneers regularly raided surviving graves for artifacts with reckless disregard to the culture and traditions of the aboriginal settlers. Long after industrialists finished grinding Mount Coffin into gravel in the 1950s, an Indian cleansing ceremony in 2004 sought to restore a spiritual balance to the site.

The Chinookan peoples did have competition from the Cowlitz tribe, whose traditional homeland was along the Cowlitz River in the foothills of the Cascades near Mount Tahoma (Mount Rainier). These people named the river Coweliskee, meaning "capturing medicine spirit." Their incredible harvests of wild game, salmon, and smelt created wealth. Cowlitz women were well known for intricately decorated, hand-woven baskets. The men became skilled horsemen, connecting with the Klickitats and Yakamas on the other side of the Cascade Mountains. The Cowlitz also took trade goods to The Dalles.

Lewis and Clark estimated the local Native American population at around 2,500 in 1805. But, by 1810, only a small band of 200 Skilloots were counted near Oak Point, just downstream from Mount Coffin. In 1842, only about 330 Cowlitz natives were living in what became Cowlitz County, and that number had shrunk to 66 by 1878.

A virulent malaria-like disease called the intermittent fever (the "cold sick") swept through native villages in the 1830s and 1840s, decimating the indigenous population. Consequently, the US government refused to ratify treaties protecting the rights of most Chinookans. The Cowlitz never signed a treaty but finally won the fight for federal recognition in 2002. Their tribal offices are headquartered in Longview today.

Hudson Bay Company (HBC) voyageurs did travel the Cowlitz Corridor between Puget Sound and HBC headquarters, first at Fort George (Astoria) and later Fort Vancouver. By the late 1830s, declining fur markets forced the HBC to pursue agricultural interests. They then built a warehouse near the mouth of the Cowlitz to store grain that the HBC shipped to Russian customers in Alaska. A priest's house nearby was used by Catholic "black robes" traveling along the corridor to pastor French Canadians and native converts.

When Americans began pouring into Oregon Country, HBC chief factor John McLoughlin advised these pioneers to settle south of the Columbia River in the extremely fertile Willamette River Valley. But when an 1846 treaty divided Oregon between the United States and Great Britain at the 49th parallel, the HBC abandoned Fort Vancouver. By the late 1840s, Americans began pushing north toward Puget Sound. One group from Indiana settled around the former HBC warehouse and established a town they named Monticello.

Founder Darby Huntington built a small hotel, store, and dock. Along with brother-in-law Nathaniel Stone and others, he attended the Cowlitz Landing Convention in 1851. The assembled pioneers sent a petition to Congress demanding separation from Oregon and the creation of "Columbia Territory" north of the river. They followed up one year later at a November 1852 meeting, hosted by Huntington, and repeated their demands. The memorial signed by the 55 delegates attending the Monticello Convention was read to the US House of Representatives just before Oregon territorial delegate Joseph Lane engineered a name change and passage of the bill creating Washington Territory in early 1853.

With Monticello as the first county seat, Cowlitz County was created in 1854. Local political rivalries led to an 1865 election moving the county government to "Nathaniel Stone's place," a mile or so upstream from Monticello. Stone named the new county seat Freeport. Voters moved the county seat again in 1872 to Kalama, the Northern Pacific terminal on the Columbia River. There it remained until 1922, when local voters moved the county courthouse to Kelso, located across the Cowlitz River from the remains of old Freeport.

By the turn of the 20th century, the local economy was centered on farming, timber, and transportation. The geography of Cowlitz County limited most farmland to flood-prone valleys. To log steep hillsides, splash dams were often built. When the dams were opened, a flood of logs swept downstream. Valleys were scoured to bedrock, destroying salmon spawning beds that still have not recovered a hundred years later. Several short-haul railroads were also built to move logs to mills or rivers. Those dumped into the Columbia River were chained into huge cigar rafts capable of being towed out to the ocean and on to the California market.

For most of its first 70 years, Cowlitz County grew slowly. It barely reached 5,000 by statehood in 1889. It took 30 years to reach 12,000 (1910). Then, the county actually lost population until Long-Bell arrived in the early 1920s. Elsewhere in Washington, growth was more spectacular, hitting a half a million by 1900. (Population growth in Cowlitz County still lags behind the state. Its 2010 census was barely 102,000, having grown only a little over 10 percent in the previous 10 years, compared to the state's 6.7 million residents and a growth rate of 14.1 percent.)

Once Long-Bell accepted his choice for locating its western operations, Wesley Vandercook focused on draining the land needed for the huge lumber mill contemplated by company directors. With costs steadily increasing, Long cast a skeptical eye toward unnecessary or extravagant expenditures.

At first, Vandercook pointed out the need to protect both the mill and employees from floodwaters. Long's earlier experiences with ramshackle mill towns springing up near his Midwest operations made him a ready listener. Using a modern urban planning ratio of 3.5 residents per worker, Vandercook explained how Long-Bell's 4,000-man workforce would bring about a town of 14,000 and then estimated the acreage needed to accommodate them. Long agreed this new town needed to be carefully planned.

But as it turned out, that would only cover about one-quarter of the valley. Vandercook then explained that without the entire valley included within his system of dikes and drainage ditches, Long-Bell workers would most likely buy the unimproved (and less-expensive) land outside the dikes. Floods would continue to threaten mill operations. When Long reluctantly agreed to his chief engineer's logic, he cast the die for planning and developing a modern industrial city of 50,000.

Almost from the beginning, Longview emerged as much more than a one-mill town. Long-Bell leaders were proud of their project and quickly saw the advantages of promoting the site to others, especially since land sales would provide relief from the sizable development costs of the diking system, roads, sewers, water lines, and electricity. Community celebrations, such as July's Go Fourth, continue that tradition of promoting Longview to new residents, entrepreneurs, and investors and building community spirit.

One obvious target for recruitment was the major landowner from whom Long-Bell had purchased its stand of virgin timber, Weyerhaeuser. Long-Bell offered to give its chief rival prime waterfront acreage. The world's top lumber company today, Weyerhaeuser maintains its sustained-yield St. Helens Tree Farm east of the Cowlitz River and a massive complex of timber, pulp, and paper mills and shipping docks in Longview.

A huge surplus of sawdust was expected from Long-Bell mill operations designed to cut one million board feet of lumber a day. Vandercook calculated that burning some could produce electricity for the mill and nearby town. Harvesting the remainder led to the creation of Longview Fibre Company, which pioneered improved techniques in creating pulp and paper out of Douglas fir and western hemlock. In time, "Fibre" became a major employer and a wholly independent company with sizeable land holdings of its own.

With dams across the Columbia River producing an abundance of hydroelectricity, the US government encouraged the construction of aluminum plants to assist in the war efforts during World War II. Reynolds Metals Company built a reduction plant in Longview just downriver from Weyerhaeuser. Reynolds more than doubled the plant within just 25 years. As the 20th century came to an end, nearly all aluminum plants in the Pacific Northwest fell victim to international competition and power production shortages. The Longview plant closed after 60 years of operation.

But back in 1922, at Long's request, his friend J.C. Nichols, a successful developer in Kansas City, traveled to the Cowlitz floodplain to provide advice for designing the new city. Nichols promptly fell in love with Fowler's Slough. He envisioned a premier residential neighborhood surrounding a manicured lake. He assembled a team of urban planners and Seattle developers who created the "planned city" as an example of the City Beautiful Movement, which was known for sweeping boulevards and stunning vistas. Today, Lake Sacajawea is considered the crown jewel of the city's park system. And its extensive urban forest garners Longview the distinction of being designated a "Tree City, USA."

City planners created distinct neighborhoods literally separated by vast tracts of vacant land and physical barriers like Lake Sacajawea. Racial segregation was also reflected in zoning codes, typical of most American cities through much of the 20th century. Large suburban lots were created in Columbia Valley Gardens. Low-cost housing was available in the Highlands Addition. Middle-income neighborhoods were given scenic names like St. Helens and Olympic. The social center of town was Hotel Monticello. Between the hotel and the lake was the Old West Side, filled with elegant homes for the city's professional and managerial residents.

A deeply religious man, Long also set the tone for addressing other social needs. He recognized the importance of churches and helped underwrite expenses for two major congregations, including

a short-lived attempt to build a single nondenominational Community Church. Today, it is joined by many Christian denominations throughout Longview. Longview's major hospital is owned and operated by the Catholic Sisters of St. Joseph of Peace.

Recreational needs were another concern of city founders. A large athletic field was built primarily for hosting baseball games. Today, there are ball fields of all types at parks throughout Longview. In addition, a YMCA was built near the eastern end of the lake as another recreation center. When combined with school facilities, Longview's recreation opportunities attract regional tournaments and even the Babe Ruth World Series.

From the original single building (named for early parks planner George Kessler), Longview's schools have grown to include numerous private and public preschools, eight public elementary schools, three public middle schools, two public high schools, and a community college. In addition, there is a public alternative online academy, as well as two private, church-affiliated schools. Longview's two public high schools are named for founder R.A. Long and Long-Bell vice president S. Mark Morris, whose primary responsibility was the development of the city. One of many gifts from Long is the Longview Public Library.

Long-Bell mill manager J.D. Tennant, Weyerhaeuser managers Al Raught and Harry Morgan, and Fibre executive Harry Wollenberg and their successors had to develop successful labor relations. The Loyal Legion of Loggers and Lumbermen (4-L) began during World War I to ensure production for the war effort. The 4-L successfully brought about an eight-hour day and a 48-hour workweek. Leaders welcomed Long-Bell and the company returned the favor. Their cooperation led to Longview setting the regional standard for pay. However, a lumber depression hit the industry in 1928, steadily worsening along with the national economy. By 1933, the industry cut wages and hours. Locally, the 4-L received much of the blame.

American Federation of Labor (AFL) affiliates recruited members, promising greater benefits. Workers first turned to the Carpenters Union, but when contract negotiations in early 1935 yielded modest gains, local members rebelled, rejecting the tentative agreement and going out on strike. National labor leaders tried to intervene, but the local labor council backed the rebels, who eventually turned to the Congress of Industrial Organization's International Woodworkers Association. Today's central labor council continues to include AFL-CIO locals along with those of the independent Association of Western Pulp and Paper Workers (AWPPW). The Port of Longview negotiates with the International Longshore and Warehouse Union (ILWU). State, municipal, hospital, and education employees also belong to a variety of unions.

Longview weathered the Great Depression, the postwar baby boom, floods and earthquakes, and even the eruption of Mount St. Helens to grow beyond its original plan. City limits encompass two-thirds of the floodplain and 36,000 residents. Much of the vacant lands have filled in the valley and up on Columbia Heights. Many new neighborhoods have been developed for all different levels of income. With an economy still heavily dependent on natural resources, Longview residents usually feel the impact of recessions harder and recover later than the rest of the nation.

Longview proved to be an expensive proposition for the Long-Bell Lumber Company. Timberland acquisition, railroad construction, an elaborate drainage system, and city construction, plus the mill itself all cost over $50 million. In 2012, that amount would equate to more than $670 million. Unfortunately, by the 1950s, most of the virgin timber had been harvested. Long-Bell was sold to International Paper Company, and the mill gradually dismantled. Today, the Port of Longview is redeveloping the mill site.

Throughout its first 90 years, Longview enjoyed many benefits provided by R.A. Long and Long-Bell. It has indeed had a remarkable record of labor stability, good paying jobs, outstanding schools, and health care facilities. Although major employers and unions have come and gone, Longview still has a reputation as a beautiful place in which to raise a family and retire.

One

R.A. Long at a Crossroads

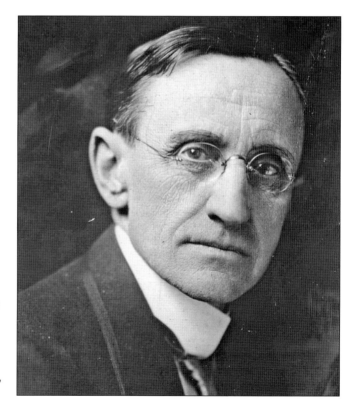

Robert Alexander Long, the chairman of the board of Long-Bell Lumber Company, was a leading citizen of Kansas City, Missouri, and, in 1920, was named national Lumberman of the Year. But the 70-year-old was not ready for retirement. With a depleted supply of resources, he led his company to acquire timberlands in the Pacific Northwest and began to build a modern industrial city—Longview. (Courtesy of Longview Room, Longview Public Library.)

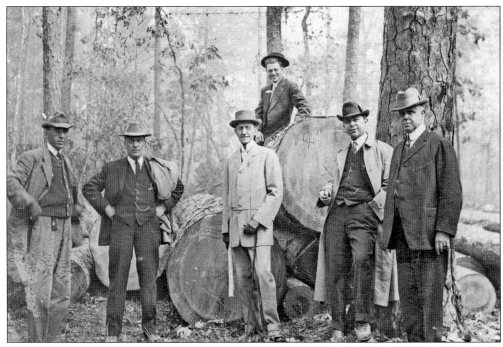

Leading figures in Long-Bell's development of its new Western Division are, from left to right, S.M. Morris, general manager for the division; Jesse Andrews, company counsel; R.A. Long, chairman of the board; Letch Letsinger; J.D. Tennant, vice president for lumber operations; and W.F. "Uncle Bill" Ryder, the one who recommended the purchase of the timberland from Weyerhaeuser. (Courtesy of Longview Room, Longview Public Library.)

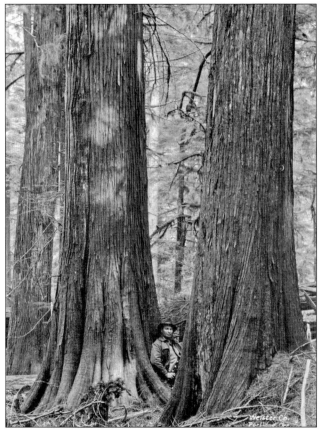

Ryder's timber revealed diameters beyond Long-Bell's experience in the South. One log contained enough lumber for a modest-sized house. (Courtesy of Longview Room, Longview Public Library.)

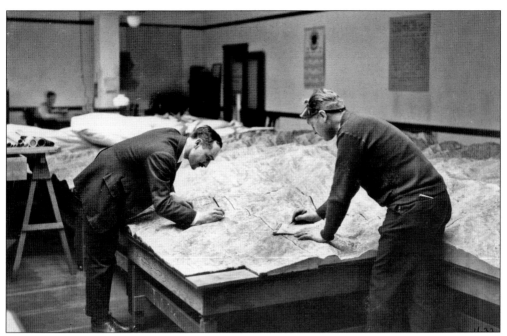

Company cartographers, George Hopkins and Walt Trantow, transformed one-foot-scale topographic maps of timber holdings and the valley floor into 3-D relief maps. (Courtesy of Longview Room, Longview Public Library.)

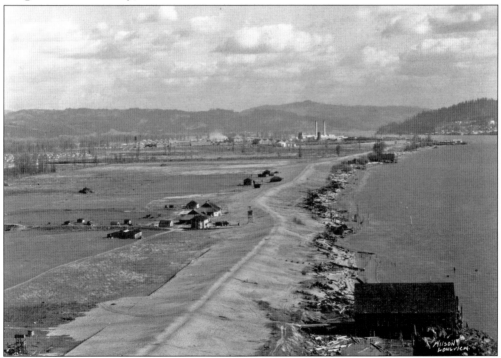

Here is an example of the levees, or dikes, constructed completely around the valley floor and far beyond the mill site, designed by Wesley Vandercook to protect employees from the annual spring floods. (Courtesy of Longview Room, Longview Public Library.)

Long-Bell's chief engineer Wesley Vandercook was responsible for draining the floodplain owned by the company. He designed a detailed system of drainage ditches and dikes, including the storage ponds and canal critical to mill operations. (Courtesy of Cowlitz County Historical Museum.)

Elaborate scaffolding was first built to hold pipes from dredges providing the material used. After 90 years, there is yet to occur any breaching of Vandercook's levies. Now operated by Consolidated Diking District No. 1, there have been numerous pumps added over the years to carry excess water as more of the valley has been developed. (Courtesy of Cowlitz County Historical Museum.)

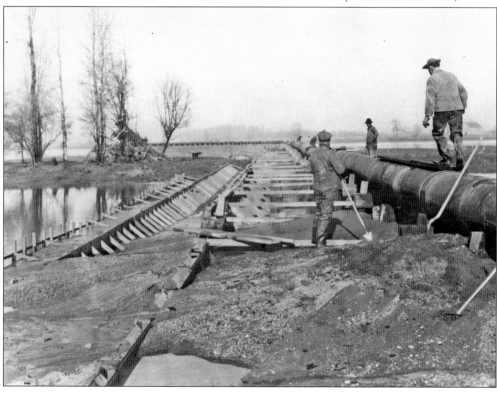

1922–1923 saw a flurry of activity. The millpond and canal from the storage lagoon were dredged just beyond the power plant with two tall smokestacks. Sawdust was to be the initial power supply. (Courtesy of Cowlitz County Historical Museum.)

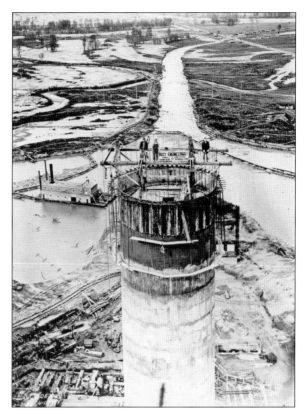

As the West Fir Mill was completed, dredging continued along the Columbia River. A dock capable of handling several ocean-going ships at once was also built. (Courtesy of Cowlitz County Historical Museum.)

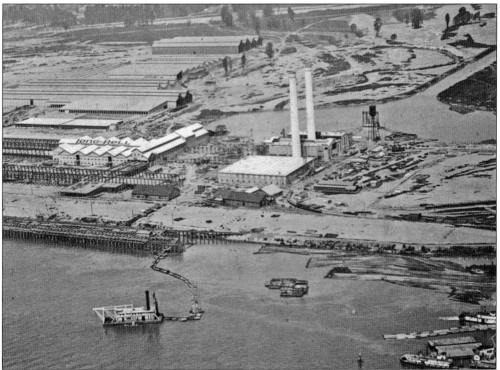

Roy Morse was in charge of the Longview, Portland & Northern Railroad, whose main function was bringing the huge timbers from the Ryderwood logging camp to the Long-Bell mills in Longview. A beloved citizen, Morse is honored by a major park in west Longview. (Courtesy of Longview Room, Longview Public Library.)

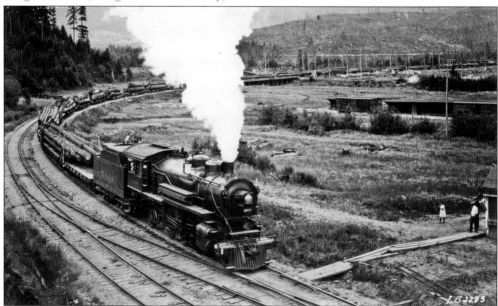

Steaming from Ryderwood loaded with logs, the locomotives traveled to Olequa Junction and then south along the west side of the Cowlitz until the flood of 1933 destroyed LP&N bridges. Afterwards, the route was via Northern Pacific Railroad tracks to the Longview Wye Junction, then back across the Cowlitz. (Courtesy of Longview Room, Longview Public Library.)

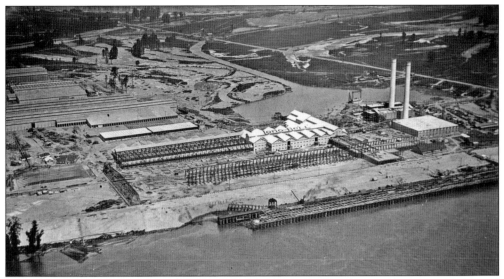

The giant Long-Bell complex cost $11 million. Seen at the top of the photograph, the LP&N dumped logs into the lagoon. The logs floated down the canal to the millpond and were then brought by conveyor into the West Fir Mill. The lumber was debarked, trimmed, sorted, planed, dried, and cooled in long sheds via a series of conveyor belts while sawdust was sent to the power plant, the building with two smoke stacks. (Courtesy of Longview Room, Longview Public Library.)

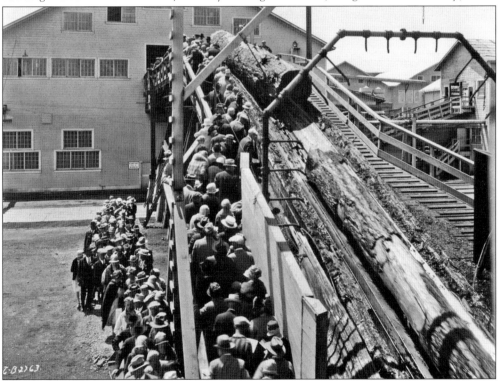

The highlight of any tour of the Long-Bell mills was the stairway to the head rig of the West Fir Mill. Guests marveled at the speed and size of logs moving into the sawmill. (Courtesy of Longview Room, Longview Public Library.)

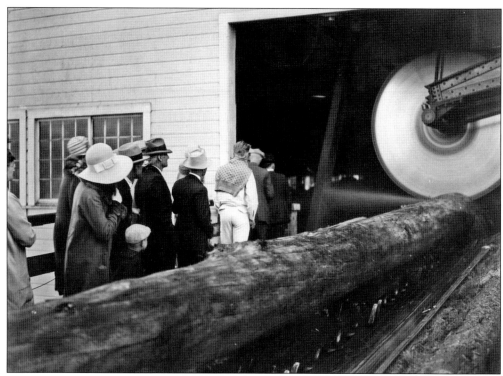

At the top of the staircase at the West Fir Mill, guests are treated to the howl of 108-inch circular saws, specially designed for the old-growth timber shipped from Ryderwood. (Courtesy of Longview Room, Longview Public Library.)

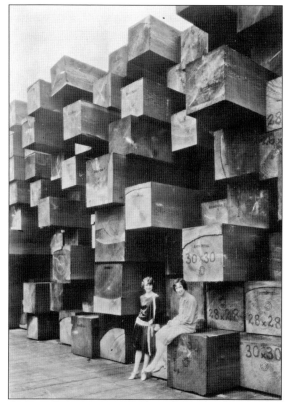

In this Long-Bell promotional photograph, Lucille Wilson and Vivian Abbott, relatives of company executives, provide scale to the giant timbers being readied for export. Called "Japanese Squares" by the marketers, each log could contain up to 5,000 feet of lumber, equal to two average Japanese houses. (Courtesy of Longview Room, Longview Public Library.)

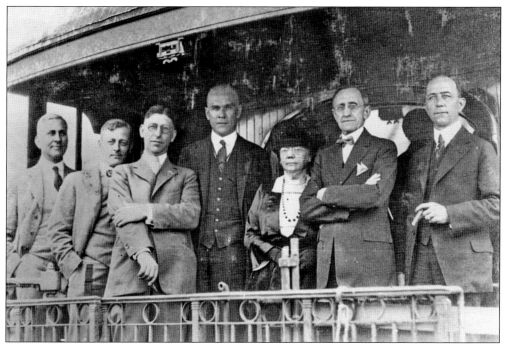

For any major celebration, such as the first anniversary of the completion of the mill in 1924, dignitaries arrived in Long's personal railroad car, the "Kymokan" (named for his favorite states). Among those with him are Wesley Vandercook (third from left), corporation counsel Jesse Andrews, Ella Long, and J.D. Tennant. (Courtesy of Longview Room, Longview Public Library.)

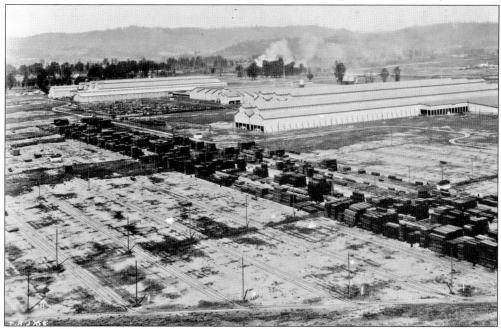

Upon completion, the Long-Bell West Fir Mill was among the world's largest, with a capacity of one million board feet of lumber per day ready for shipment by rail or water—an accomplishment worth celebrating. (Courtesy of Cowlitz County Historical Museum.)

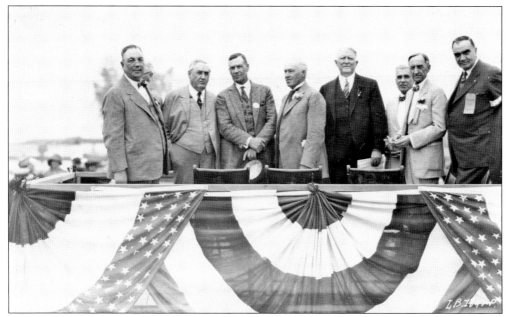

Let the celebrations begin! From left to right, Mayor A.L. Gibbs, Washington governor Louis Hart, US senator Wesley Jones, J.J. Donovan of Bellingham's Bloedel-Donovan Lumber Company, and prominent Texas lumberman John H. Kirby join M.B. Nelson, R.A. Long, and Portland mayor George Baker at the podium. (Courtesy of Longview Room, Longview Public Library.)

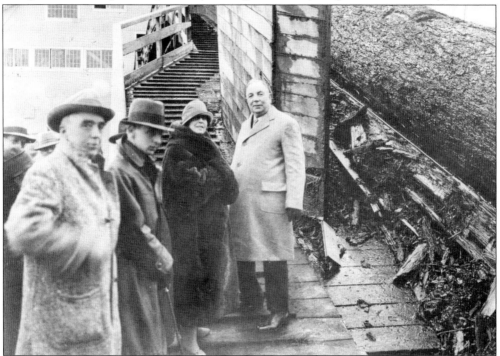

Also enjoying the festivities at the Long-Bell mill complex were, from left to right, S.M. Morris, Prince Nicholas and Queen Marie of Romania, and Longview mayor A.L. Gibbs. (Courtesy of Cowlitz County Historical Museum.)

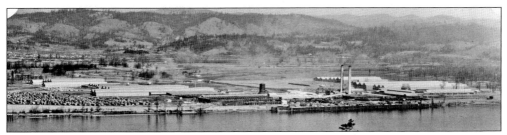

By 1925, both the West Mill and the East Mill had been completed. The East Mill was used for smaller logs. Lumber from both mills was shipped either by rail or over the docks. (Courtesy of Cowlitz County Historical Museum.)

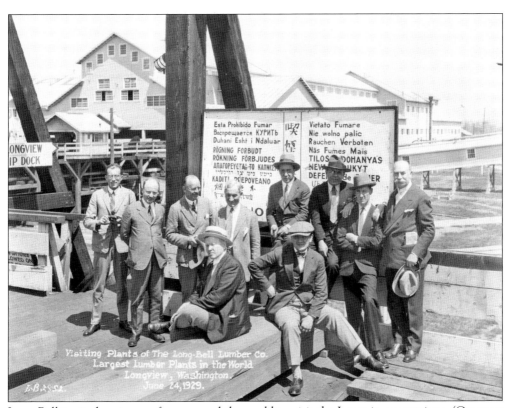

Long-Bell invited customers from around the world to visit the Longview operations. (Courtesy of Cowlitz County Historical Museum.)

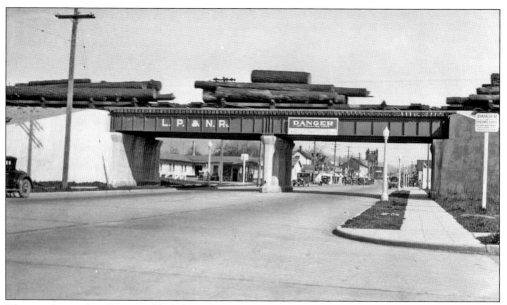

The steady supply of logs rumbled through town on LP&N's tracks built on a causeway. The tracks were abandoned after the 1933 flood, and the causeway was dismantled during World War II. (Courtesy of Cowlitz County Historical Museum.)

Intense competition occurred between the managers of the two mills. Manager B. Howard Smith poses in front of his West Mill. When J.W. Lewis transferred from Louisiana in 1926 to run the West Mill, Smith took over the East Mill. At full capacity, each mill could produce one million board feet of lumber a day. (Courtesy of Cowlitz County Historical Museum.)

Two

THE LOWER COWLITZ
RIVER VALLEY

On this excerpt of a 1919 map prepared by the US Army Corps of Engineers to show "the lay of the land," swampy conditions throughout the Cowlitz Delta were indicated. A primitive road network connected West Kelso with Freeport to the south, a few farm families along the shores of Fowler's Lake, and LaDu, a settlement farther west at Mount Coffin. It met another road from Kelso at the northern tip of Fowler's Lake, continuing along the foot of Columbia Heights (north of West Kelso). Before Longview, the farmers eked out a meager living, battling annual floods. Pioneers told stories of watching steamboats plying the floodplain between Mount Solo (north of Mount Coffin) and Columbia Heights during high water. (Courtesy of the Rare Documents Collection, Cowlitz County Historical Museum.)

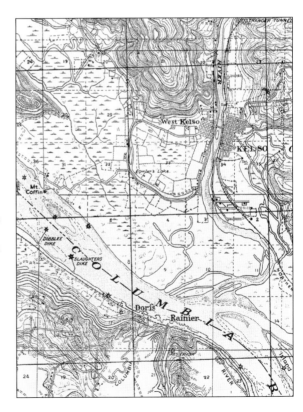

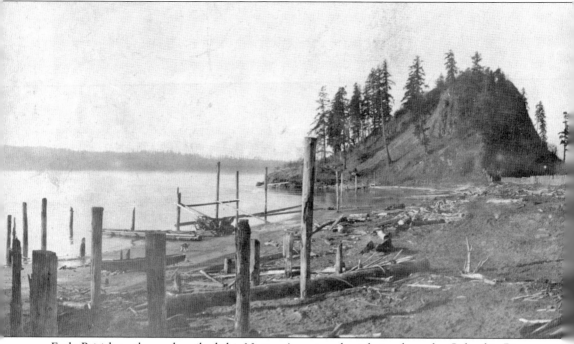

Early British explorers described this Native American burial site along the Columbia River as "festooned with canoes." Some estimated its height as 300 feet. US Navy lieutenant Charles Wilkes described a fire torching it in 1841. Grave robbers defiled the canoe-coffins. Later, it was

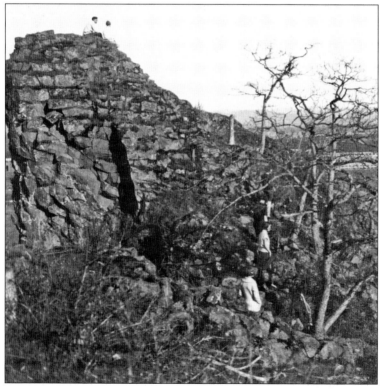

Bush owned it from 1863 until he sold it in 1906 to a gravel company that installed rock crushers to supply material for dikes and roads, reducing its girth to this by the early 1930s. Weyerhaeuser Timber Company finally acquired the leveled remains of the rock in 1952. Its base is still visible to employees of the company's chemical plant. (Courtesy of Cowlitz County Historical Museum.)

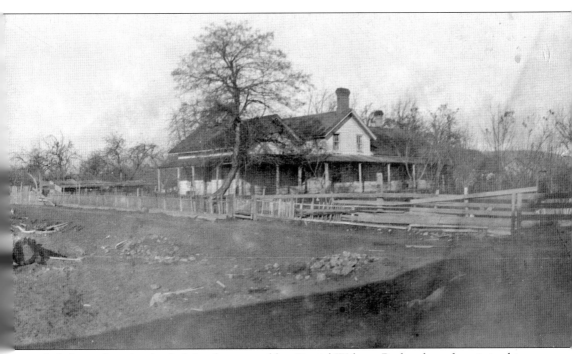

included in a donation land claim that was sold to Daniel Webster Bush, whose farm is in this photograph. (Courtesy of Cowlitz County Historical Museum.)

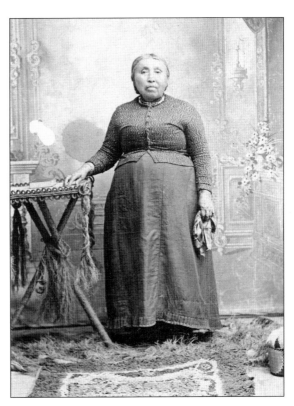

Because of the inhospitable conditions in the Cowlitz Delta, few Native Americans lived there. Mount Coffin was considered sacred ground, as well. Cowlitz Indian Mary Pete and her son Charlie did live in a shack across the delta on the Olson farm between Catlin (now West Kelso) and Freeport until around 1900. Without a reservation of their own, local Cowlitz members typically fished for salmon and smelt and took farm labor jobs, such as picking hops. (Courtesy of the Hattie Barlow Olson Collection, Cowlitz County Historical Museum.)

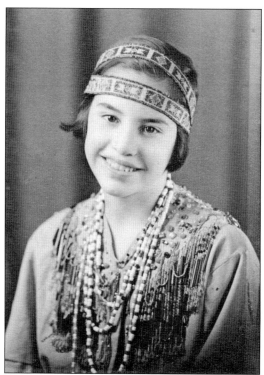

Granddaughter of Cowlitz chief Jack Wannassay, Jacqueline Wannassay Hill is from one of the families that survived the plagues that were so brutal to tribes in the 19th century. The Cowlitz Nation refused to agree to treaty terms offered in the 1850s. The federal government did not formally recognize the Cowlitz until the 21st century. (Courtesy of Cowlitz County Historical Museum.)

Cowlitz women were well known for their basket weaving, like the one shown by Mary Ike. They produced baskets for sale as well as for personal use. Upriver Cowlitz men were recognized as excellent horsemen and frequently traveled across White Pass to be with families on the Yakama Reservation. (Courtesy of Cowlitz County Historical Museum.)

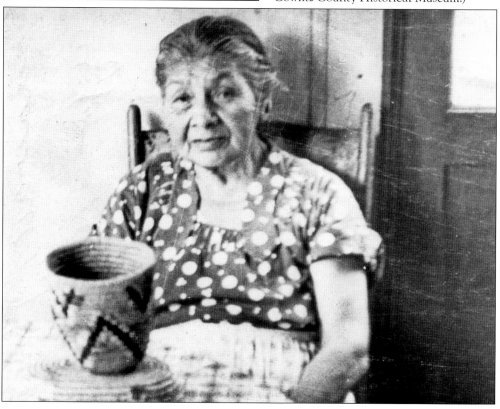

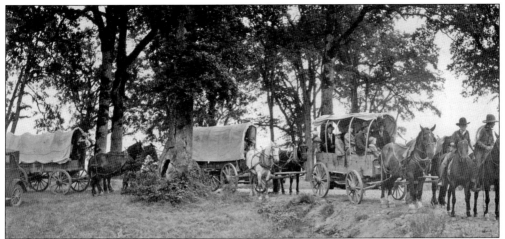

Most Americans arriving in the Pacific Northwest via the Oregon Trail used covered "Conestoga" wagons, which were sturdy enough to last the arduous 2,000-mile journey across deserts and high mountains ranges. By the late 1840s, pioneers turned north to the Cowlitz Corridor, long used by Indians, trappers, priests, and agents of the Hudson Bay Company (HBC), travelling between Fort Vancouver and Puget Sound. This photograph is of a 1922 reenactment. (Courtesy of Longview Room, Longview Public Library.)

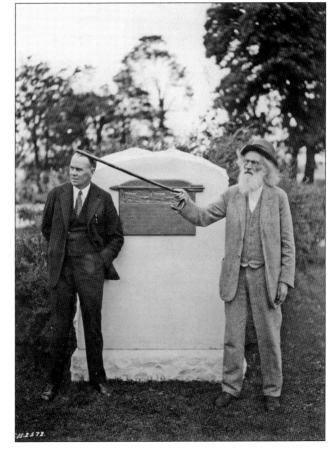

One of those Oregon Trail pioneers was Ezra Meeker, who lived for a short time near today's Kalama (1853–1854). In his later years, he promoted the Pacific Northwest and books he wrote while recrossing the Oregon Trail numerous times. He came to Longview in 1926 and met with local officials such as hotelier David Boice at the Jefferson Square (civic center) monument to the Oregon Trail. (Courtesy of Longview Room, Longview Public Library.)

One pioneer who remained on the Cowlitz was Harry Darby "Uncle Darby" Huntington, leader of an extended family from Indiana who settled on the west bank in abandoned HBC buildings, including a priest's house. He built a dock, house, and store. Brother-in-law Nathaniel Stone eventually settled upstream and founded a rival town called Freeport. Others settled nearby donation land claims of up to 640 acres. (Courtesy of Cowlitz County Historical Museum.)

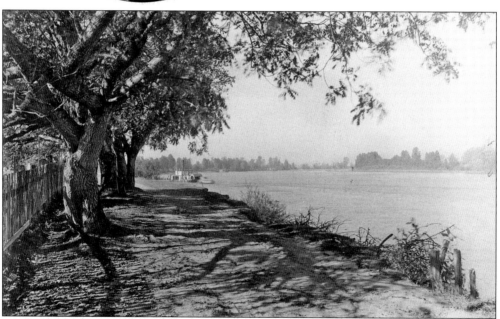

Founded by Huntington in 1849, Monticello was the first town on the west bank of the Cowlitz. Named county seat in 1854, it lost that designation to Freeport shortly before 1867 floodwaters swept the buildings away. Named for the home of Huntington's political hero, Thomas Jefferson, it is pronounced with a soft "c" sound, rather than the Italian "ch" sound Jefferson preferred. (Courtesy of Longview Room, Longview Public Library.)

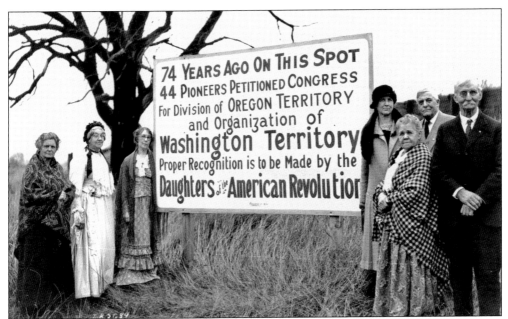

In 1852, Huntington hosted a meeting of pioneers agitating for separation from Oregon Territory in the old priest's house. The memorial agreed to by those pioneers was crucial in the Congressional debate over their request in 1853. It took a name change from "Columbia" to "Washington" to persuade a pro-slavery Congress to honor the first president, a Southerner, with a new territory carved out of Oregon. This photograph is of a 1927 DAR reenactment. The reenactors' sign mislabeled this site. The petition was signed at the original Monticello about a mile upstream. (Courtesy of Longview Room, Longview Public Library.)

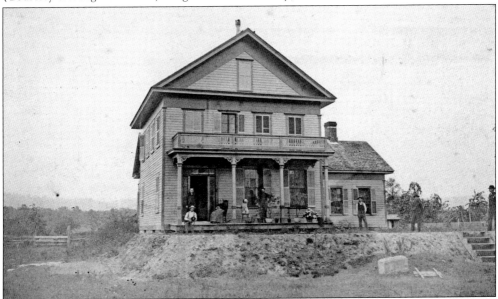

Following the disastrous flood of 1867, Huntington moved his enterprises to high ground downstream from the original location and built a new house. Here it is in 1894 with Huntington's widow, Rebecca, sitting on the porch surrounded by surviving children. Huntington died in 1882 and is buried in Catlin Cemetery. (Courtesy of Cowlitz County Historical Museum.)

At its centennial, a permanent monument marking the site of the Monticello Convention was dedicated in 1952 along California Way in Longview. These grandchildren of the pioneers attended the ceremony: Mrs. Harry E. Brewster, granddaughter of "Uncle Darby," and George Plomondon, grandson of Simon Plomondon. When Tennant Way, a limited-access highway, replaced much of California Way in the 1960s, the state highway department eliminated this roadside marker. (Courtesy of Cowlitz County Historical Museum.)

A new site was chosen near the Longview Public Library, and the memorial was expanded to include interpretive panels identifying both the 1852 meeting as well as an earlier convention held in 1851 at Cowlitz Landing (now Toledo). Here, local historian and editor of the *Longview Daily News* John M. McClelland Jr. (center) tells the story of the move to create a new territory north of the Columbia River at the 1960 rededication. (Courtesy of Cowlitz County Historical Museum.)

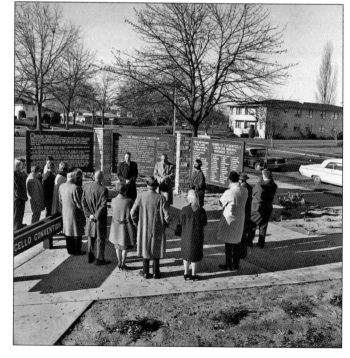

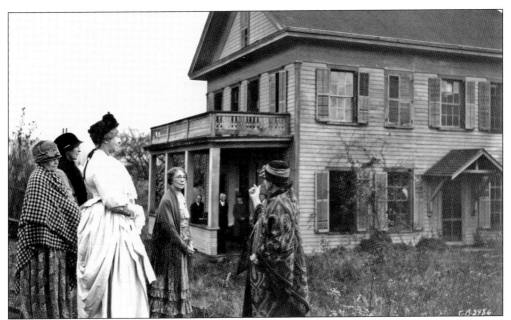

The 1927 reenactors, including Hattie Barlow Olson (wearing glasses, in center), witnessed the dilapidated condition of the Huntington House. Shortly after this event, the structure collapsed during the building of the dike across the old townsite. The only remaining evidence is the walnut tree by the sign in the previous DAR photograph. (Courtesy of Longview Room, Longview Public Library.)

Alexander Abernathy was another pioneer settler in this area, but his home and sawmill were on Oak Point down the Columbia River from the flood-prone Cowlitz Delta. He became a local elected county official. This house was built in 1853 but is no longer standing. (Courtesy of Cowlitz County Historical Museum.)

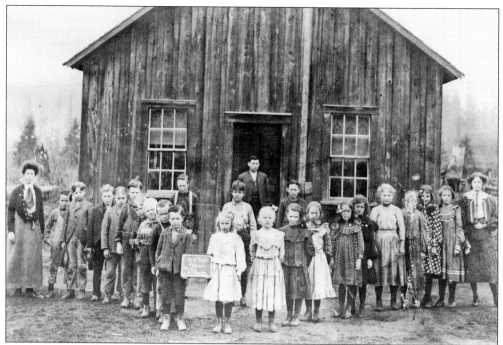

In 1895, Washington state passed milestone legislation called the "Barefoot Boy School Act," to finance schools for all of the state's children. Parents in most rural areas organized public school districts. This one at Oak Point was eventually consolidated into the Longview School District in the 1920s, and students were bussed to modern schools in town. (Courtesy of Cowlitz County Historical Museum.)

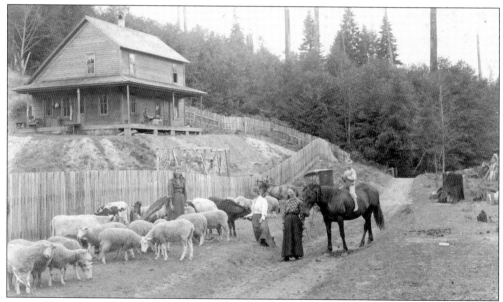

Over 100 years ago, Hazel Dell Road was this dirt path on the way to Castle Rock. William T. Bourland is sitting on the porch watching his family tending the sheep and cows. Note the horse-drawn buggy in the center. This house burned down in 1917. (Courtesy of Cowlitz County Historical Museum.)

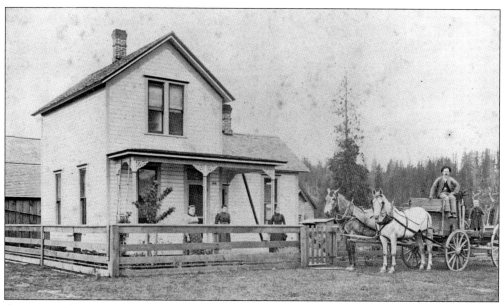

George Fouth owned this small farm closer to the Cowlitz Delta in Catlin (now West Kelso). Note the barn behind the house. It was not uncommon for local farmers to tend crops out in the delta but live in town. (Courtesy of Cowlitz County Historical Museum.)

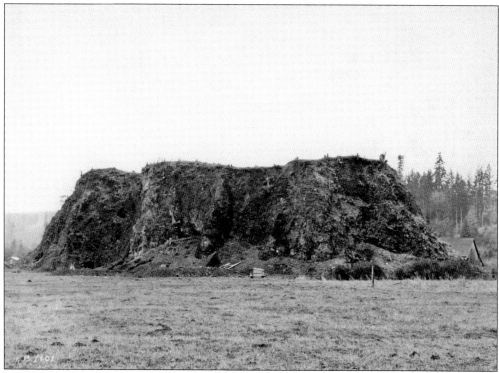

One of the bigger farms north of Fowler's Lake included this large rocky outcropping. Named Huntington Rock, it has been reduced to a fraction of its original size over the years but is still visible near Northlake Avenue in the Terry-Taylor Addition. The Huntington-Taylor-Swanson farmhouse is still visible from Pacific Way. (Courtesy of Longview Room, Longview Public Library.)

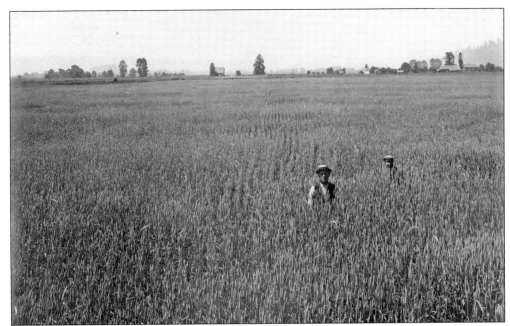

These men standing in a lush field of grain provide proof that in good years farming can be successful in the Cowlitz Delta. They are west of Fowler's Lake. Mount Solo is off to the right. Mount Coffin is still tall enough to poke through the trees on the left. (Courtesy of Cowlitz County Historical Museum.)

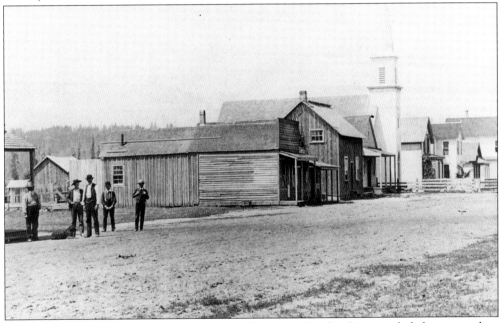

In 1891, Main Street in Freeport, running parallel to the Cowlitz River, included stores, a shoe repair shop, a hotel, a Presbyterian church, and several homes. The church was later barged across the river to Kelso. Only one structure remains, which is found at the foot of Hudson Street, but the road still goes north from there and is called River Road today. (Courtesy of Cowlitz County Historical Museum.)

This was the unpaved county road near the north end of Fowler's Lake. It is close to the intersection with another county road from Kelso, similar to today's Nichols Boulevard and Ocean Beach Highway. (Courtesy of Longview Room, Longview Public Library.)

With few voters in the Cowlitz Delta, the county government did not pave many roads like this one, heading down from Columbia Heights. When the Northern Pacific Railroad built a terminal at Kalama in 1872, voters moved the county seat there from Freeport. But in 1922, voters moved the county seat to Kelso, based in part on the increase in voters working here for Long-Bell. This road was paved and became Pacific Way. (Courtesy of Cowlitz County Historical Museum.)

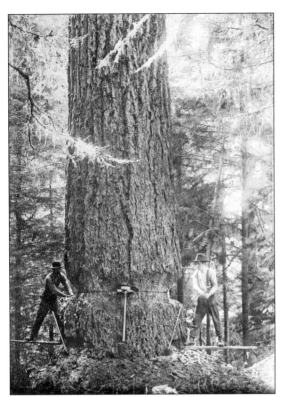

One hundred years ago, cutting these huge timbers was laborious. Lumberjacks stood on springboards to chop away the bark so that they could get to the wood with their two-man crosscut saw, wedges, and sledgehammers. Note the oil bottle used to dissolve pitch deposits on the saw. Rumors of huge trees like this attracted timber scouts like W.F. Ryder to southwest Washington. (Courtesy of Cowlitz County Historical Museum.)

Before trains could be built, loggers needed oxen to drag huge logs to the mill or riverside to be dumped. Smaller, short logs would be cut and laid along the route for the huge logs as "skid roads." (Courtesy of Cowlitz County Historical Museum.)

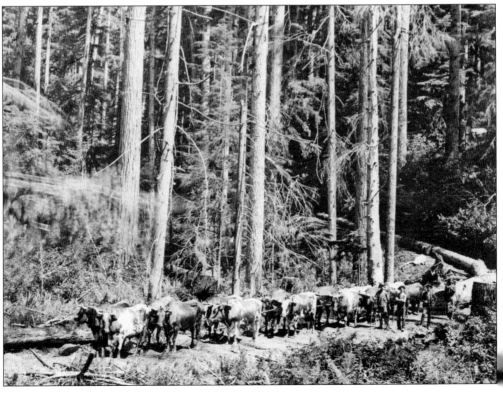

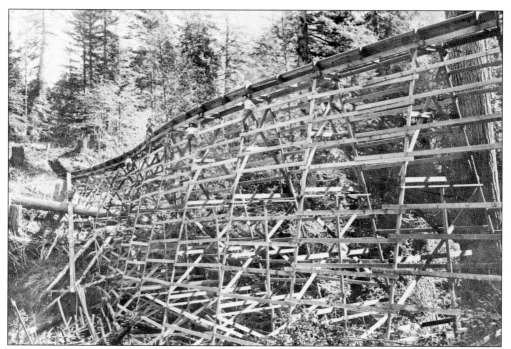

Before there were logging trucks and roads, flumes on top of trestles were used to move logs over steep valleys or hillsides. Through these chutes, logs could quickly slide, a concept that gave inspiration to modern-day amusement rides. (Courtesy of Cowlitz County Historical Museum.)

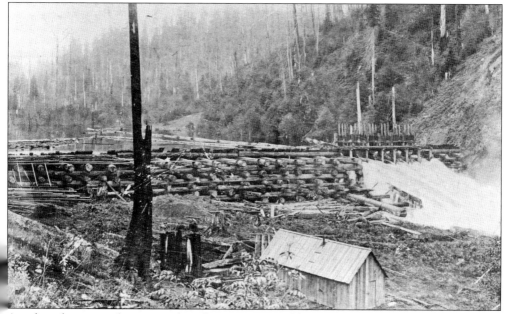

Another alternative for moving logs downstream quickly was a splash dam, like this one near Baird Creek on the Coweeman River. First, logs would be dumped behind the dam. Once the spillways were opened, logs would go crashing down the valley in destructive floods that scoured the riverbeds to the bedrock—damage still visible there 100 years later. (Courtesy of Cowlitz County Historical Museum.)

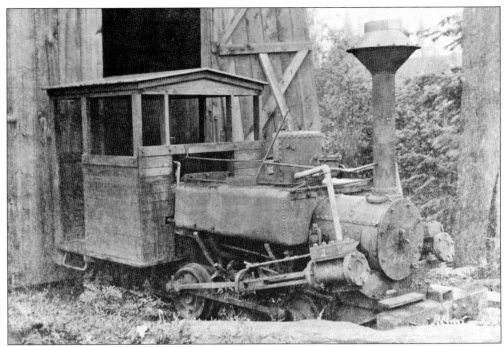

Eufaula Heights logger Benjamin Franklin Brock bought the "Ant" for $2,000 in 1883. It was the first logging locomotive in this area. It was donated to the LP&N Railway in 1924 and finally sold for scrap during World War II. (Courtesy of Cowlitz County Historical Museum.)

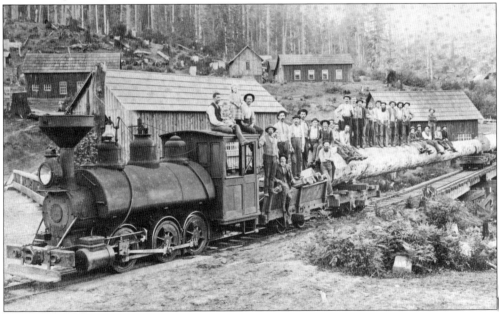

B.F. Brock called his short-haul train the Mosquito & Coal Creek Railroad. It ran between Coal Creek Slough and Eufaula Heights, where his logging camp was located. Although his first locomotive was the Ant, Brock eventually purchased a bigger one, shown here with a crew apparently impressed with its more powerful engine. Mosquito Creek was later renamed Harmony Creek. (Courtesy of Cowlitz County Historical Museum.)

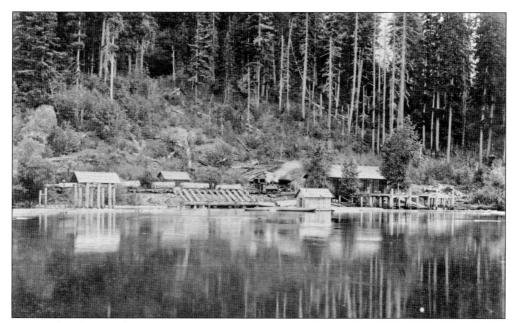

Once railroads arrived, transporting logs became simpler. Here, the Ant is at the end of the track where logs were dumped into the Columbia River at Coal Creek Slough. (Courtesy of Cowlitz County Historical Museum.)

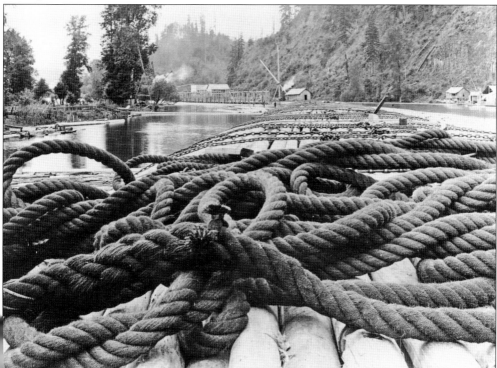

Coal Creek Slough was where logs were assembled into seaworthy "cigar rafts." The heavy tow ropes and thick chains were necessities for the ocean voyage to the California market. (Courtesy of Cowlitz County Historical Museum.)

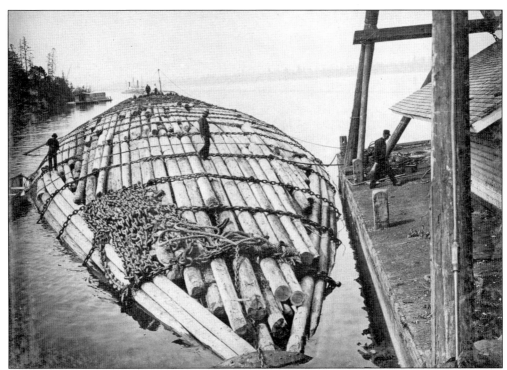

At the foot of a floating crane used to stack the logs, these workers swiftly wrapped thick chains tightly around the raft of logs. (Courtesy of Cowlitz County Historical Museum.)

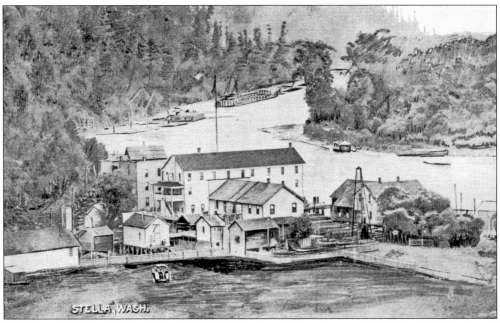

At the western end of the slough, Stella was where the rafts met the Columbia River and were prepared for being towed downriver and out into the Pacific. Note the cradle used in the construction of the rafts and the cranes used for stacking the logs at the center of this postcard. (Courtesy of Cowlitz County Historical Museum.)

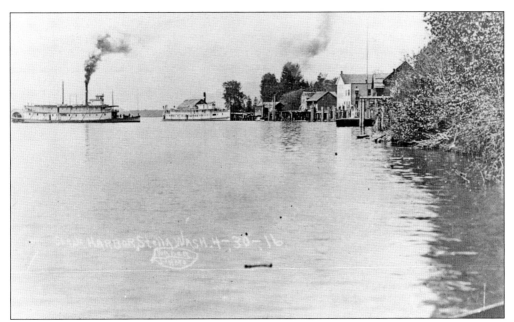

By 1916, Stella served as the staging area for cigar rafts and as a major dock for stern-wheelers plying the Columbia River between Astoria and Portland. At the mouth of Germany Creek, Stella only consists of a few buildings today. (Courtesy of Cowlitz County Historical Museum.)

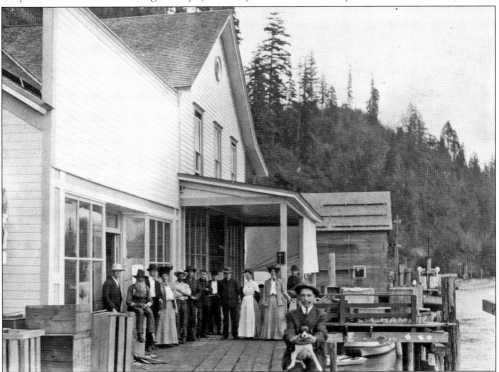

One hundred years ago, Stella attracted a sizable contingent of Eastern European immigrants, including the Dragich, Zdilar, and Sudar families, eager to own farms and timberland up Germany Creek. Stella became their community center. (Courtesy of Cowlitz County Historical Museum.)

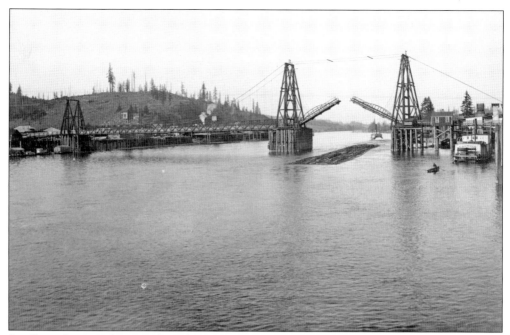

Smaller rafts were also towed up the Cowlitz River to mills, especially shingle mills. Here, the Allen Street Bridge is being opened for one such raft and its tugboat. The logged-off hill beyond the bridge is where Lynnwood Drive is today. Note the tombstones visible in Catlin Cemetery. (Courtesy of Cowlitz County Historical Museum.)

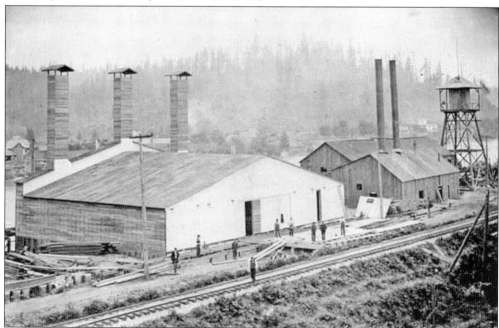

Shingle mills were an important source of employment in Kelso. This is Duff's Shingle Mill, just upstream from the Allen Street Bridge. After it burned down in the mid-1890s, it was replaced by the Crescent Shingle Mill, which was in operation when Longview was founded across the river. (Courtesy of Cowlitz County Historical Museum.)

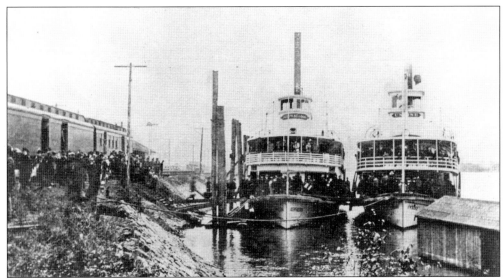

Since the early fur-trapping days, the Cowlitz River has been an important transportation corridor, even as technology changed. Here, passengers from the Kelso Railroad Station walk down the embankment to climb on board the steamboats, waiting to take them farther downstream toward Astoria. (Courtesy of Cowlitz County Historical Museum.)

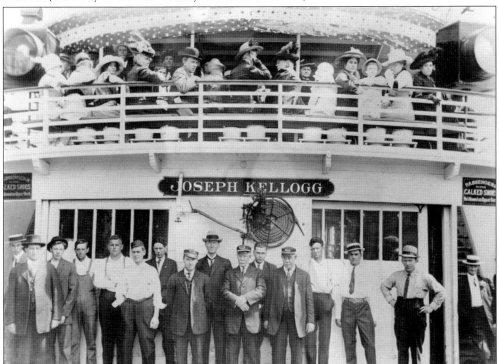

One of the best-known stern-wheelers plying the local waters was the *Joseph Kellogg*, a name long associated with the transportation industry along the Cowlitz River. Here, passengers and crew pose for the photographer. The man with the white mustache at the center of the crew is Capt. Joseph Kellogg. Note the warning over the stairways for loggers wearing caulk boots. (Courtesy of Cowlitz County Historical Museum.)

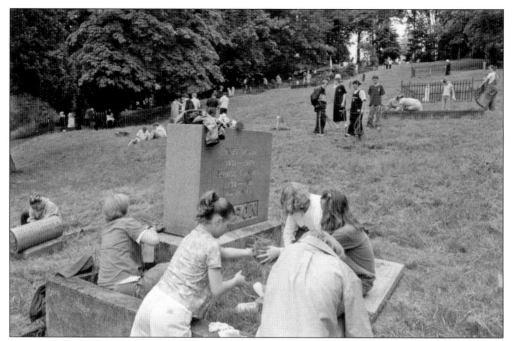

On the hillside above West Kelso is Catlin Cemetery, where many pioneer settlers are buried. Because the cemetery generates no revenue for maintaining graves and tombstones, students from Kelso's Huntington Junior High School (now Middle School) perform critical community service by cleaning the historic site. The graves of Freeport residents Cliff Olson and his wife, Eunice, are being cleaned here. (Courtesy of Cowlitz County Historical Museum.)

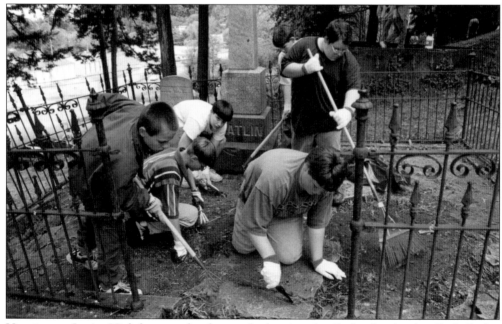

Huntington Junior High boys are hard at work cleaning the Catlin family plot. Seth Catlin attended the Monticello Convention and served in the territorial legislature. (Courtesy of Cowlitz County Historical Museum.)

Three

THE PLANNED CITY

7 points about
LONGVIEW
Washington

The New
Industrial City
of the Pacific
Northwest

This is a proof of Long-Bell advertising for leading magazines, such as *Literary Digest*, extolling the virtues of Longview—"The Industrial City of the Pacific Northwest." (Courtesy of Longview Room, Longview Public Library.)

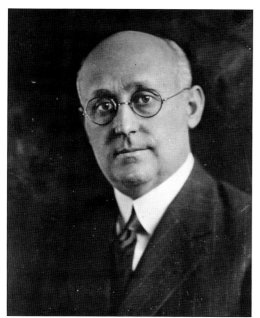

Once R.A. Long agreed to build a modern city, he turned to his friend J.C. Nichols (1880–1950), a prominent Kansas City developer, best known for the Country Club District there, the nation's first "master planned community." Upon traveling to the Cowlitz flood plan, he enthused about its development potential, especially utilizing Fowler's Lake. He commissioned architectural firm Hare & Hare to develop the plans for Longview. (Courtesy of Cowlitz County Historical Museum.)

Hare & Hare designed Longview to reflect the values of the City Beautiful Movement, with broad vistas and boulevards radiating from a civic center to the industrial centers and to take advantage of Fowler's Lake. (Courtesy of the City of Longview Building and Planning Department.)

Long-Bell's chief engineer Wesley Vandercook oversaw the design and development of the flood plain's elaborate diking and drainage system. He calculated the storage capacity needed to handle annual freshets through winding ditches and overflow storage that included the sculpted city center lake and pasture lands past Columbia Valley Gardens. He also supervised construction of the many miles of dikes that have successfully held back floodwaters from the rivers for 90 years and still counting. (Courtesy of Cowlitz County Historical Museum.)

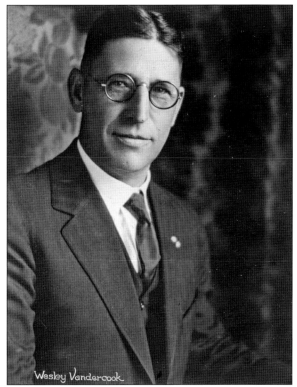

Wesley Vandercook

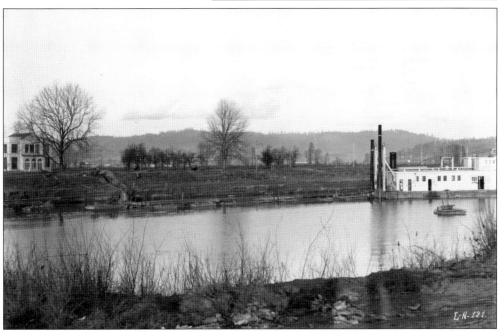

Fowler's Lake needed a lot of deepening, and the surrounding neighborhoods needed a lot of fill. So, dredges were moved overland from the rivers to facilitate the project. Note the pipe from the dredge up the bank to the left. The company held a contest among schoolchildren to rename the lake. The winning entry: Lake Sacajawea. (Courtesy of Cowlitz County Historical Museum.)

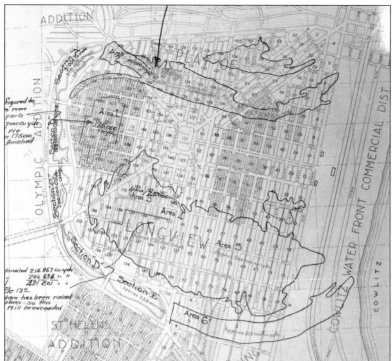

This excerpt from Hare & Hare's plan shows how the lake was altered and how low-lying fields were filled with dredge spoils (arrows). Note the original name for the boulevard on the south and west side of the lake: Missouri. It was later renamed for Nichols, the only compensation he received. (Courtesy of the City of Longview Building and Planning Department.)

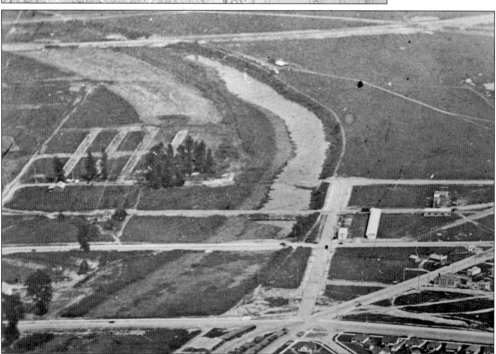

This aerial photograph shows the soon-to-be abandoned section called Area 6. Today, only a portion of it remains preserved as wetlands near Tennant Way and Seventh Avenue. The major intersection at the bottom is Fifteenth Avenue and California Way. (Courtesy of Longview Room, Longview Public Library.)

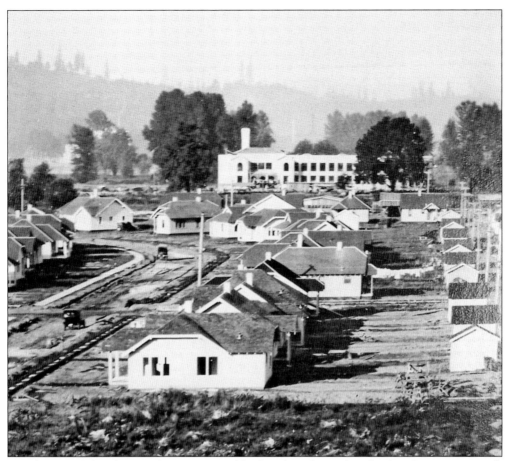

One feature of the plan was distinctive neighborhoods with nearby schools. This is Nineteenth Avenue in the St. Helens Addition, just across the lake from Kessler School. (Courtesy of Longview Room, Longview Public Library.)

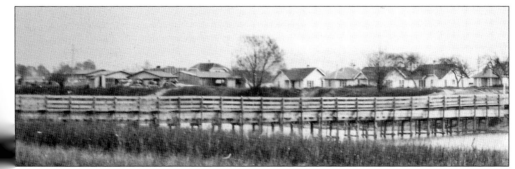

Youngsters reached school originally across a footbridge at Twentieth Avenue, which has long since been replaced by a wooden bridge big enough to handle cars and trucks. (Courtesy of Longview Room, Longview Public Library.)

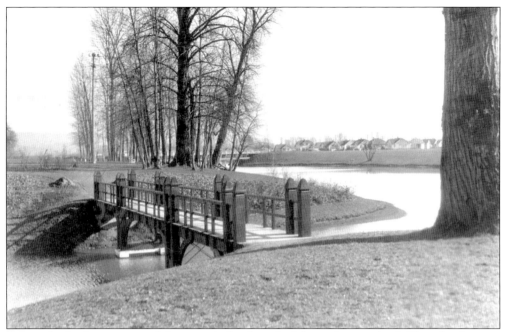

Fancier footbridges connected the several islands in the lake to the mainland. This island is near today's Elks War Memorial Building at Twenty-first Avenue and Kessler Boulevard. The Twentieth Avenue Bridge is in the distance. (Courtesy of Longview Room, Longview Public Library.)

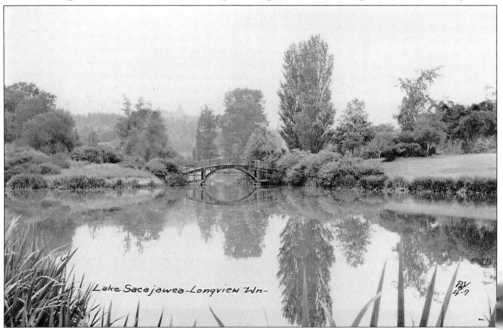

Another ornate footbridge provided access to what is called Lion's Island today, near the Washington Way Bridge. These wooden footbridges fell into disrepair and were removed during the 1930s. The one to this island today is mostly a landfilled causeway. The only other one replaced looks similar to this and was installed in the early 2000s, a gift from Weyerhaeuser and Longview's Japanese sister city, Wakoh. (Courtesy of Longview Room, Longview Public Library.)

City planners left a lot of vacant land anticipating future growth. Early residents often complained about the vast stretches they had to cross. The Community House (YMCA) and Longview Memorial Hospital sit at the end of the lake. Longview Community Church is at center left. In the lower left is the sports stadium. Beyond the open fields past R.A. Long High School is Columbia Valley Gardens. (Courtesy of Longview Room, Longview Public Library.)

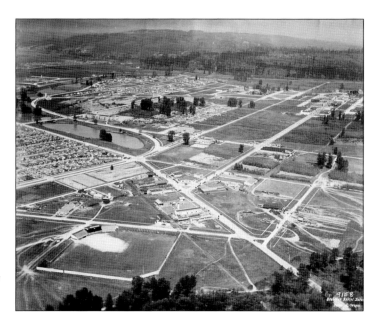

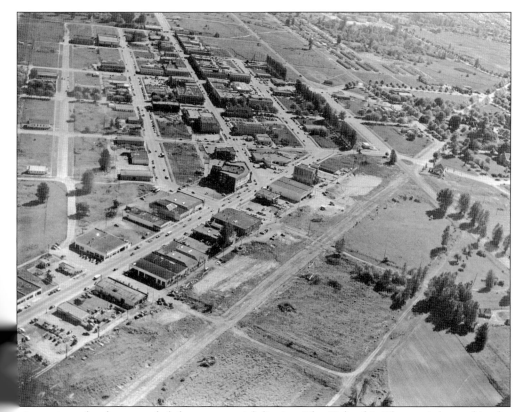

More vacant land surrounded the commercial district. The Columbia Theater is located in the center of this photograph. Barracks-style postwar housing (called Huntington Villa) is in the upper-right corner. (Courtesy of Cowlitz County Historical Museum.)

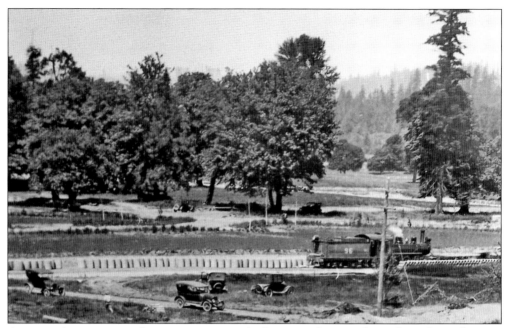

A tremendous amount of concrete pipe was laid to provide sewer lines throughout the city. Providing ease of transport, temporary small-gauge railroads were built. Here is one at the future civic center near the Hotel Monticello, which was then under construction. (Courtesy of Longview Room, Longview Public Library.)

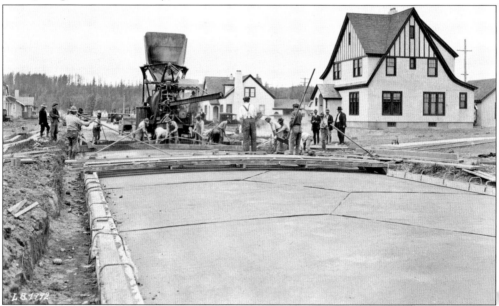

The company sought innovative and economic techniques for pouring concrete streets. Here, on Washington Way, unique hexagon-shaped pours illustrate one such technique. By avoiding 90-degree angles, the cement only needed to be four inches thick, rather than the typical six. A lengthy cure time of 10–14 days also strengthened the pavement. Nearly all of these types of streets are still in use and are in remarkable condition after 90 years. (Courtesy of Cowlitz County Historical Museum.)

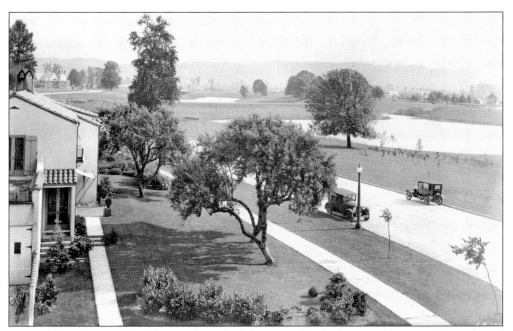

J.C. Nichols's dream of lovely homes along the lake was realized. This scene along Kessler Boulevard is looking south toward the Community Church under construction in the mid-1920s. (Courtesy of Longview Room, Longview Public Library.)

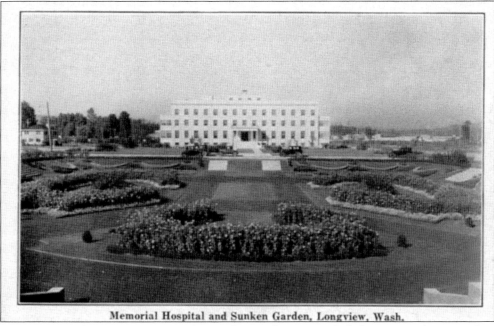

Memorial Hospital and Sunken Garden, Longview, Wash.

To counteract fears of going into a hospital, city planners included a contemplative sunken garden across from Longview Memorial Hospital. (Courtesy of Longview Room, Longview Public Library.)

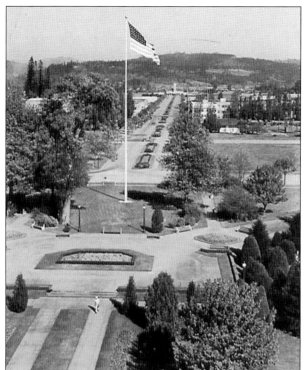

Other unique features of this planned city included a theater, community house, public library, railroad station, and a newspaper. But the center of the city was Jefferson Square, designed for grand vistas and public buildings. This view is from the hotel across the square and down Broadway toward the railroad station. (Courtesy of Longview Room, Longview Public Library.)

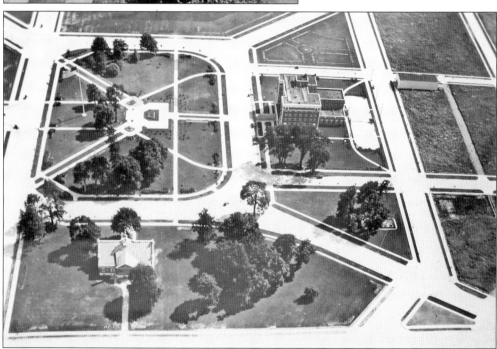

The crowning achievement of this civic center was the Hotel Monticello. It soon came to be the social center of Longview, as well. In this aerial view, the hotel's tennis court is visible behind. A small zoo is in the trees just to the south. Below the square is the public library. (Courtesy of Longview Room, Longview Public Library.)

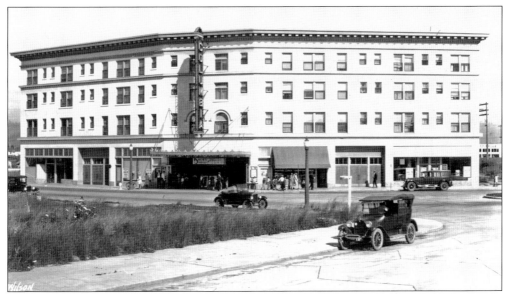

Wesley Vandercook took another role in leading the efforts to build a first-class vaudeville theater as a way of advancing the city that he played such an enormous role in building. Now, 90 years later, the theater still anchors an arts-and-entertainment district in downtown Longview. (Courtesy of Longview Room, Longview Public Library.)

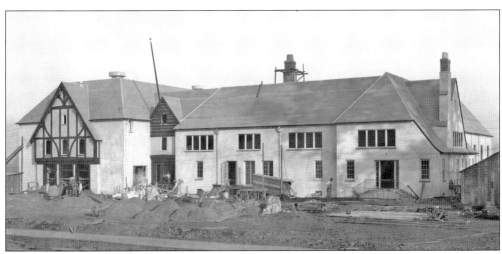

City founders built a recreation center, known as Community House, which included a swimming pool, auditorium, gymnasium, and meeting rooms. They soon converted the facility into a YMCA, which it remains today. (Courtesy of Cowlitz County Historical Museum.)

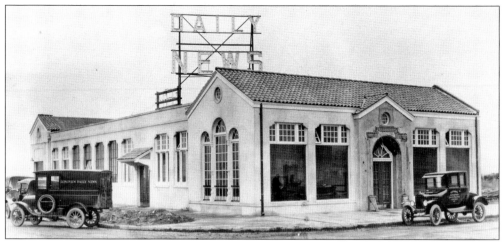

S.M. Morris believed that an independent newspaper was critical to the future success of Longview and was instrumental in recruiting a relative, John M. McClelland, to come to Longview and publish the *Daily News*. It became an award-winning newspaper, winning the coveted Pulitzer Prize for reporting the eruption of Mount St. Helens in 1980. (Courtesy of Cowlitz County Historical Museum.)

McClelland was an unabashed booster of Longview and used his newspaper to extol the virtues of the planned city. His front-page editorials were unusual, as were the paper's various promotional contests. His family continued to publish the *Daily News* for three generations. (Courtesy of Cowlitz County Historical Museum.)

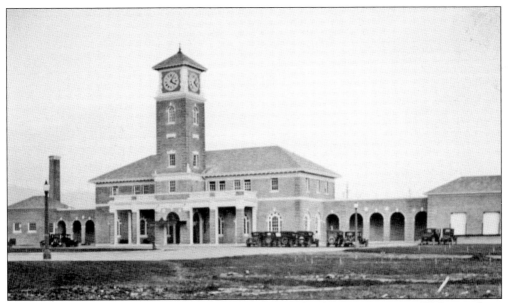

Another element in the planned city was access to national rail passenger service. With main lines running through neighboring Kelso, the Northern Pacific could only be persuaded to schedule daily stops in Longview after R.A. Long personally built the station at the foot of Broadway as well as bridges across the Cowlitz. (Courtesy of Longview Room, Longview Public Library.)

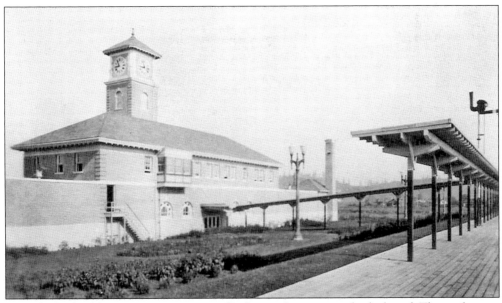

From the back of the station, passengers walked up to the trains to climb aboard. The tracks were elevated on causeways through town. Service abruptly ended after four years, when the 1933 flood destroyed the bridges. (Courtesy of Longview Room, Longview Public Library.)

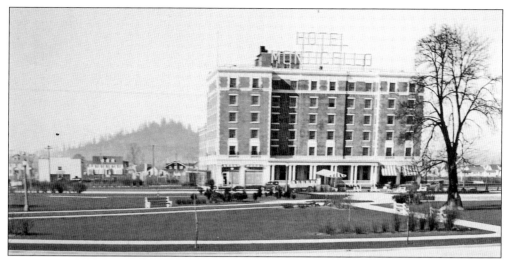

The Hotel Monticello quickly became the pride and joy of early Longview residents. As the neighborhood filled in toward the lake, it became known as the Old West Side, as it was west of the hotel. The white building to the left is the original Olympic Movie Theater. Just to its left was the Longview Hotel. Both were demolished in later decades. The large white house with dormers is the Vandercook Mansion, home of the chief engineer. Mount Solo is in the background. (Courtesy of Longview Room, Longview Public Library.)

Felker Morris (Tucker), daughter of S.M. Morris, enjoyed the hotel porch with its grand, imposing columns. (Courtesy of Longview Room, Longview Public Library.)

Another unique characteristic of the planned city was the variety of housing options available to newcomers seeking work and a place to raise families. At first, they could get tent or trailer accommodations at the tourist camp, set amidst a grove of oaks. It remained a trailer court, later called the Oaks, well into the 21st century until replaced by a Walmart Superstore. (Courtesy of Longview Room, Longview Public Library.)

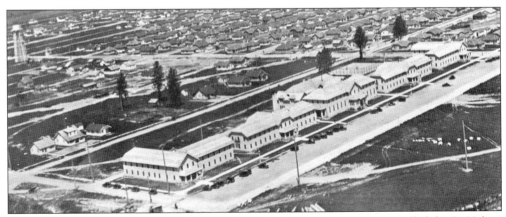

Another option for single men was the row of dormitories along Oregon Way, called the St. Helens Inn. Only one of these buildings remains today—still reserved for single men. Note the city's water tower on the left. It was in the Highlands Addition, developed in the late 1920s. (Courtesy of Longview Room, Longview Public Library.)

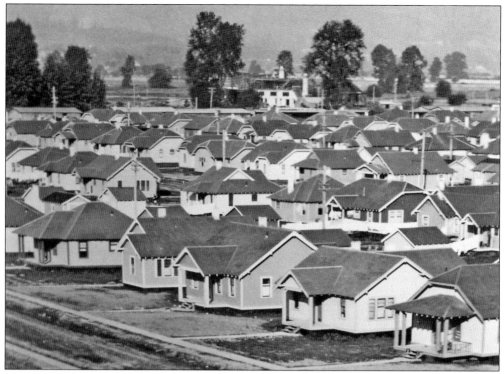

The company built a lot of affordable single-family homes for workers, especially in the St. Helens Addition south of the lake. Mass-produced with only a few varieties in style, these homes remain largely intact. This scene is from Fifteenth through Eighteenth Avenues. The YMCA is visible between the trees. (Courtesy of Longview Room, Longview Public Library.)

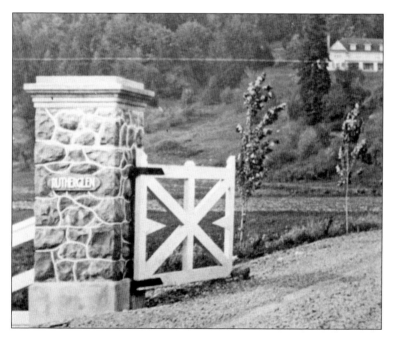

J.D. Tennant, Long-Bell vice president for mill operations, adopted a more elegant lifestyle at Rutherglen Mansion on the slopes of Mount Solo. (Ruth was his wife.) He could monitor the mill operations by analyzing the smoke pouring out of the stacks across town. Today, it is a restaurant and bed-and-breakfast. (Courtesy of Longview Room, Longview Public Library.)

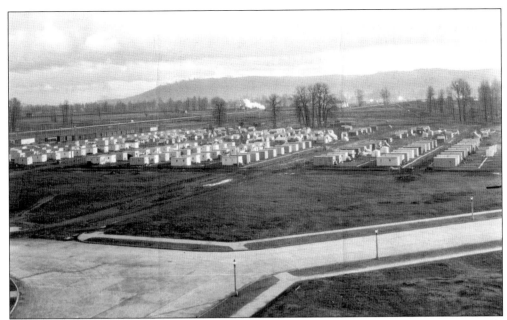

One very temporary housing solution was this neighborhood of two-room shacks, built originally for logging camps and skidded into place. Here, just off of the civic center, townspeople referred to them as Skidville. Ella Long, wife of the company owner, Robert A. Long, complained bitterly about being able to see them from her room in the Hotel Monticello. (Courtesy of Longview Room, Longview Public Library.)

Real estate sales were a high priority while the hotel and civic center were being developed. The outlines of Broadway are taking shape in this photograph. The building was replaced by an insurance office at the corner of Fourteenth Avenue and Broadway. (Courtesy of Longview Room, Longview Public Library.)

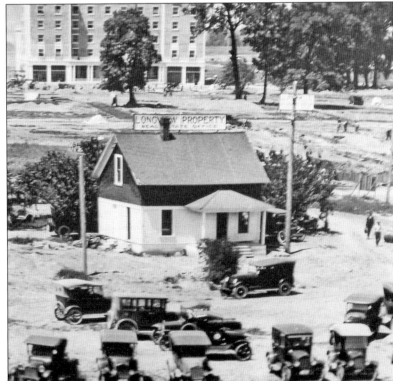

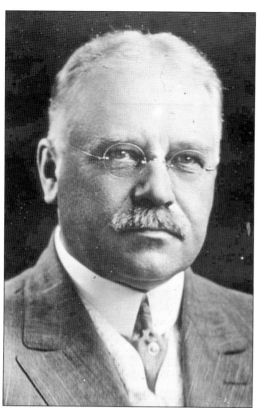

George Kessler (1862–1923) was hired to design the parks system for Longview but tragically died early in 1923. A protégé of the famous urban park planner Frederick Law Olmstead, Kessler championed the City Beautiful Movement. Among many Midwest projects, he designed Longview Farm for R.A. Long. He called for neighborhood parks to complement the beautiful lake envisioned by J.C. Nichols. The city's first school building and the boulevard on the east and northern shore of the lake were named in his honor. (Courtesy of Cowlitz County Historical Museum.)

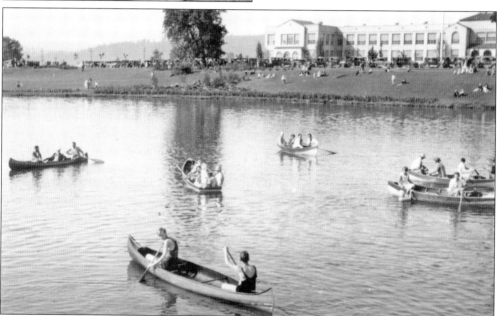

Kessler's enduring legacy in Longview is Lake Sacajawea Park. He wanted parks that were not only visually exciting but were multiple-use facilities. Kessler School is in the background. The lake was cited in 2012 as a major reason Longview was named "One of America's Ten Prettiest Towns" by *Forbes* magazine. (Courtesy of Cowlitz County Historical Museum.)

Four

MORE THAN A
ONE-MILL TOWN

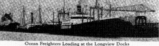
Another in a series of advertising in national magazines, this one touts the reasons why Longview would be attractive to other industries. (Courtesy of Longview Room, Longview Public Library.)

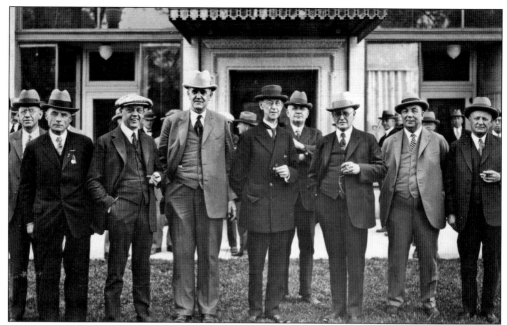

By the early 1920s, salvage logging in Clark County's 1902 Yacolt Burn was ending for Weyerhaeuser Timber Company. George S. Long (1853–1930), in charge of the Tacoma company's Pacific Northwest operations, shifted his attention to the estimated 30 billion board feet between the Cowlitz River and Mount St. Helens. Timber surveys and railroad construction lasted from 1922–1928. Long (center, in black hat) was not related to Longview founder, R.A. Long. (Courtesy of Cowlitz County Historical Museum.)

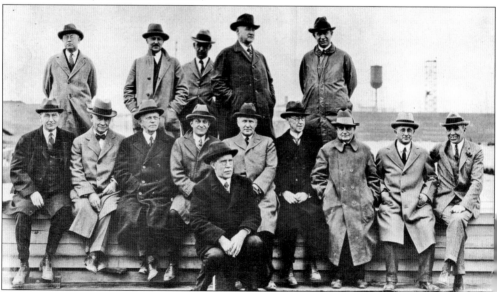

Weyerhaeuser was Long-Bell's first target for industrial expansion. Weyerhaeuser executives including George S. Long (seated fourth from right) and mustached John P. Weyerhaeuser Sr. (front row), met in May 1924 with Long-Bell officials, including S.M. Morris (far right), Wesley Vandercook, and W.F. Ryder (top row, third and fourth from left). (Courtesy of Cowlitz County Historical Museum.)

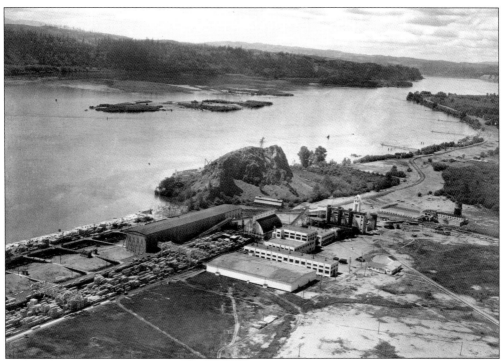

When Long-Bell offered Weyerhaeuser three potential mill sites upriver from Mount Coffin, all three were accepted to the surprise and excitement of the Longview officials. Designed for huge old-growth Douglas fir, Mill No. 1, with a capacity of 600,000 board feet daily, opened in 1929 and was located next to the cargo dock. Its lumber was destined mostly for California and markets back East. (Courtesy of Cowlitz County Historical Museum.)

Cutting the massive old-growth timbers into lumber required a skilled crew of saw filers. Here, one is working on a band saw in Mill No. 1. (Courtesy of Cowlitz County Historical Museum.)

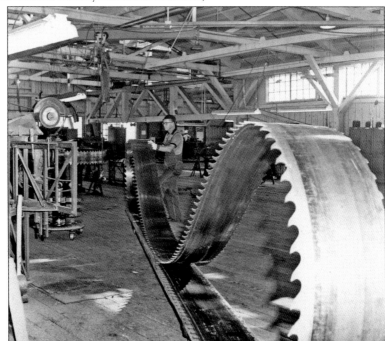

Weyerhaeuser appointed Harry Morgan Sr. (left) and Al Raught (right) to build the Longview operations into a modern complex that included three sawmills, a shingle mill, a planer mill, a plywood mill, and a Prestolog mill. The two also became active civic leaders, at one point supplying lumber to construct cabins at the Spirit Lake Y Camp near Mount St. Helens. (Courtesy of Cowlitz County Historical Museum.)

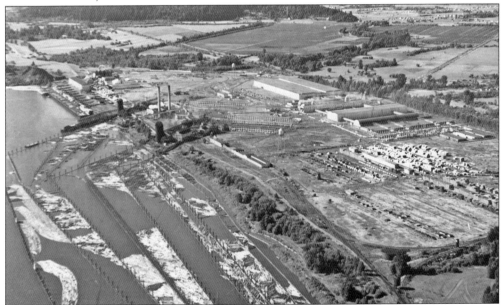

Weyerhaeuser trains would dump logs into the Columbia River "log pond" near the Longview-Rainier Bridge. From there, they would be sorted by size and sent down "raceways" to bull chains that sent them up into head rigs for cutting at the appropriate mill. The log pond/raceway system was abandoned in 1968, when sorting started to be done on land. Note that Mount Coffin on the left is smaller than in earlier photographs. (Courtesy of Cowlitz County Historical Museum.)

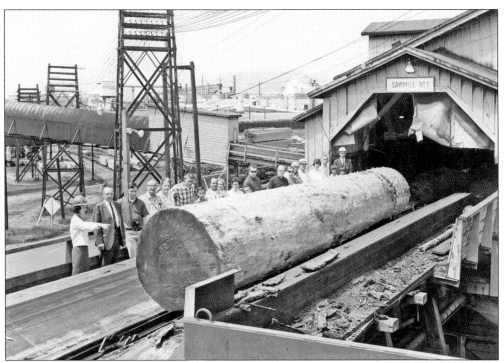

One favorite highlight of tours at the Weyerhaeuser mills was watching huge logs enter the head rigs. This is at Mill No. 1. (Courtesy of Cowlitz County Historical Museum.)

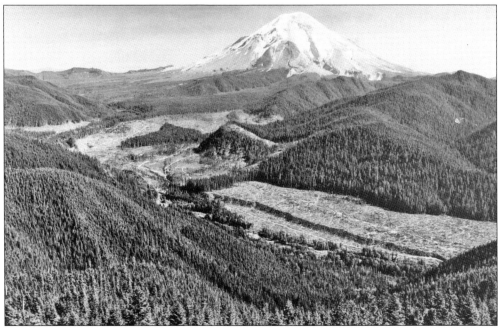

As the old growth was harvested, Weyerhaeuser adopted a high-yield management goal and created the Mount St. Helens Tree Farm to insure a regular supply of logs for the mills through replanting, thinning, clear cutting, and other state-of-the-art techniques. A portion of the tree farm is shown with Mount St. Helens in the background. (Courtesy of Cowlitz County Historical Museum.)

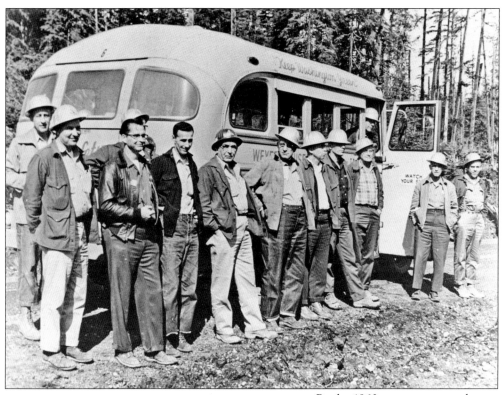

By the 1960s, crews—not only of loggers but also of engineers and managers—such as Dick Fatheringill, Frank Stevens, Alden Jones, and Otto Reisk, were traversing the St. Helens Tree Farm on Weyerhaeuser's fleet of buses. (Courtesy of Cowlitz County Historical Museum.)

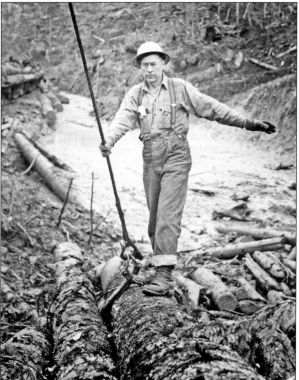

Weyerhaeuser logger Russ Carmichael is setting a grapple hook around a smaller log to be yarded up above the creek. More recent environmental regulations now prohibit logging in and through creek drainage and require a buffer strip on either side of a creek. (Courtesy of Cowlitz County Historical Museum.)

One of the biggest challenges for both Long-Bell and Weyerhaeuser was what to do with the waste wood. Longview's combined sawmills could cut over three million board feet of lumber a day at full production. That generated tons of sawdust, bark, and scrap. Ideally, they were used to fuel steam generators to provide electrical power to the mills. Still, there were piles of excess waste, shown here at Longview Fibre. (Courtesy of Cowlitz County Historical Museum.)

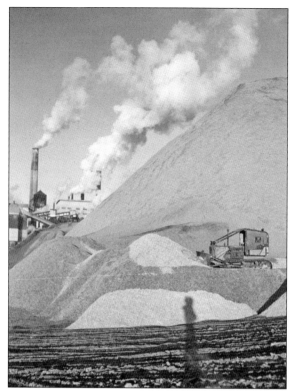

One traditional strategy was to burn the wood waste in tall wigwam-shaped burners, sending acrid smoke and burning embers into the atmosphere. Both large and small mill towns across the nation were familiar with burners like these at Longview Fibre. Eventually, they were all eliminated due to strict environmental regulations. (Courtesy of Cowlitz County Historical Museum.)

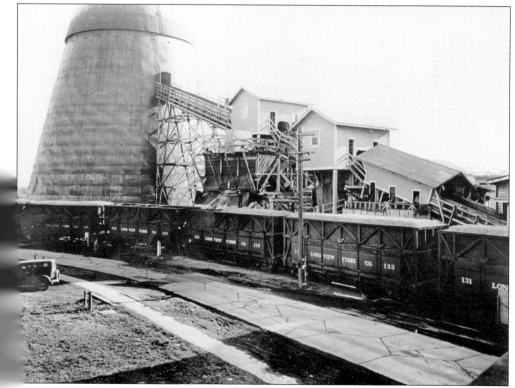

To frugal managers, utilization of wood waste led to development of creative products: laminated beams for churches, presswood boards for kitchen cabinets, and even sawdust Prestologs for home fireplaces, like the ones being delivered to a local ski lodge. But even these innovations still left considerable waste wood. (Courtesy of Cowlitz County Historical Museum.)

For most managers, pulp and paper production was the best, most-profitable answer. Long-Bell wanted to form a subsidiary with Wisconsin papermaker Monroe Wertheimer. Instead, Wertheimer teamed up with Boston businessman Harry Wollenberg to establish Longview Fibre Company, whose No. 5 paper-machine is shown here. (Courtesy of Cowlitz County Historical Museum.)

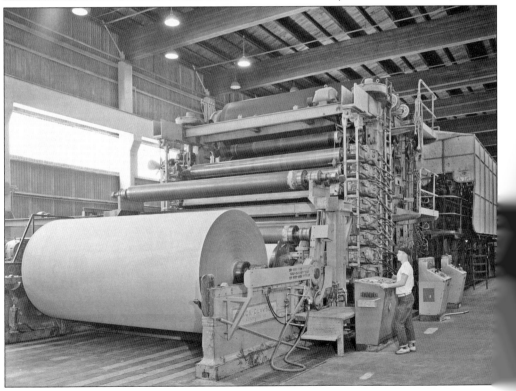

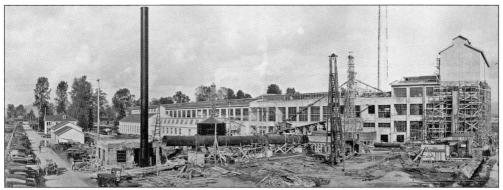

This 100-ton-a-day Longview Fibre mill, shown under construction in 1927, was located east of the Long-Bell complex near the mouth of the Cowlitz River. On the right is the tall, vertical digester building. The left-side house was the room for the No. 1 machine. Note that the original office building is on the left. By 1998, Fibre had grown to 12 machines capable of producing 3,500 tons a day. (Courtesy of Cowlitz County Historical Museum.)

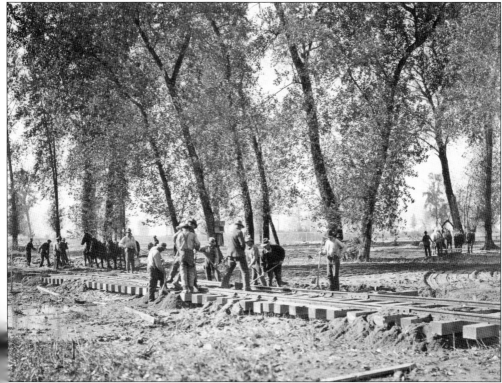

Until 1956, Long-Bell owned a little over 10 percent of the stock in Fibre and sent an executive to serve on the Fibre board of directors. At least initially, Long-Bell supplied the wood chips used by Fibre, much of it being sent "next-door" by rail. Here, those tracks are being laid through a grove of trees between the mill sites. (Courtesy of Cowlitz County Historical Museum.)

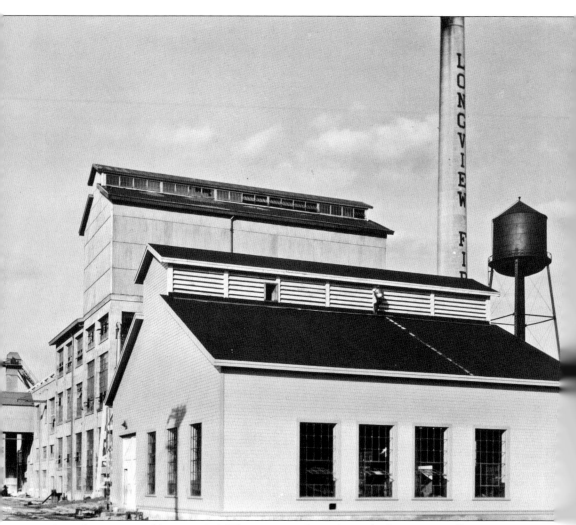

As its business steadily expanded, Fibre continued to rely on the Longview mill site as its main pulp-and-paper facility. This meant constant renovations and additions, both to increase capacity as well as to adapt to the latest technology. This is one of the first additions built, the Maintenance Building, located just to the right of the construction above. (Courtesy of Longview Room, Longview Public Library.)

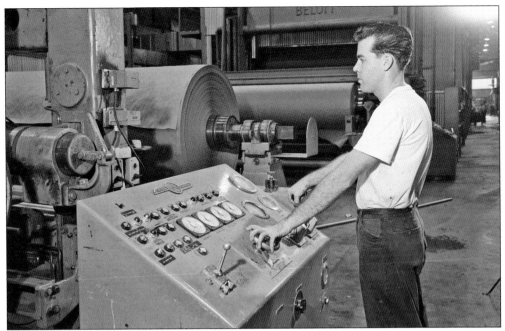

This paper-machine operator is at the control of modern General Electric winder controls. Although known locally as Fibre, the industry recognized the high quality of paper produced here as Longview paper. Used primarily for retail and industrial packaging, Fibre products also include corrugated boxes and, until recently, grocery bags. (Courtesy of Cowlitz County Historical Museum.)

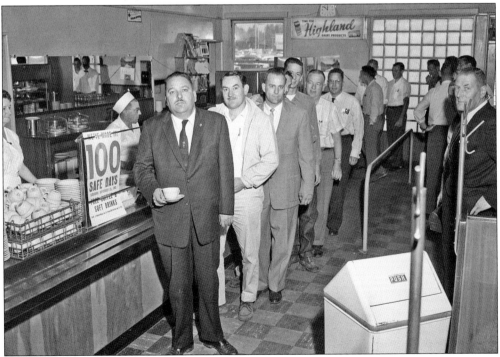

Mill safety is always a top priority. Here, workers are rewarded for attaining a 100-day safety record. They are lined up in the mill cafeteria. (Courtesy of Cowlitz County Historical Museum.)

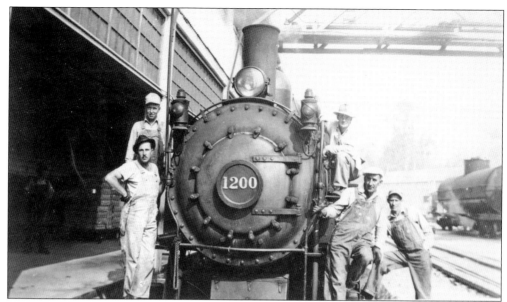

Railroads were key transportation modes for Fibre, not only in receiving raw materials but also in shipping finished products. (Courtesy of Cowlitz County Historical Museum.)

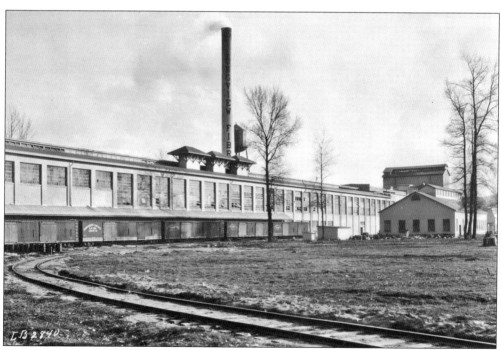

Fibre shipped by rail in early days. Boxcars were loaded at each machine and pulled to the Longview switching yard just off-site. Here is where product from the No. 1 paper-machine was loaded. Note the vertical digester building on the right. (Courtesy of Longview Room, Longview Public Library.)

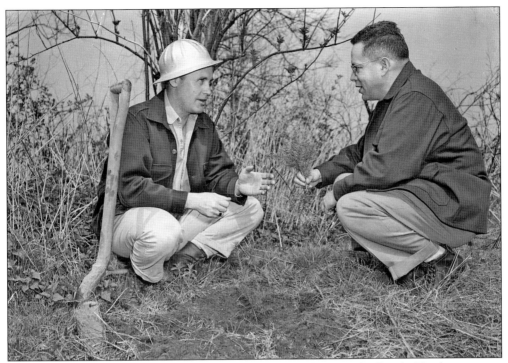

As demand increased, Fibre invested in its own timberlands across the Pacific Northwest, using trucks increasingly to bring in needed wood chips. Here, Fibre timber vice president Lee Robinson (left) discusses tree-planting strategies with CEO R.P. "Dick" Wollenberg, son of the company founder. (Courtesy of Cowlitz County Historical Museum.)

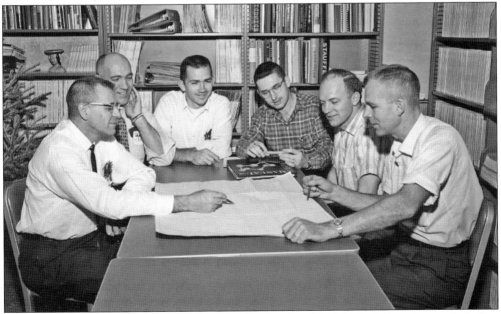

To keep its competitive technological edge, Fibre employed highly skilled engineers, including (at end of table, from left to right) Jim Stacie and Bob Guide. (Courtesy of Cowlitz County Historical Museum.)

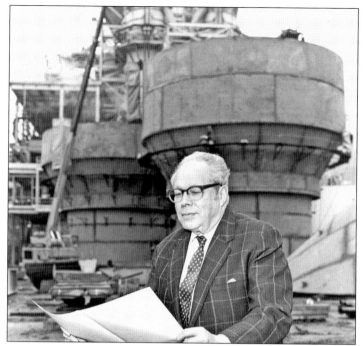

Acknowledged leader of Fibre during much of the last half of the 20th century, R.P. Wollenberg maintained a strong commitment to employees, providing steady employment during periodic economic downturns. He and his wife, Lee, also made generous contributions to the community, including support of the Toutle River Boys Ranch, the Lake Hospital Guild, local colleges, and the Southwest Washington Symphony. (Courtesy of Cowlitz County Historical Museum.)

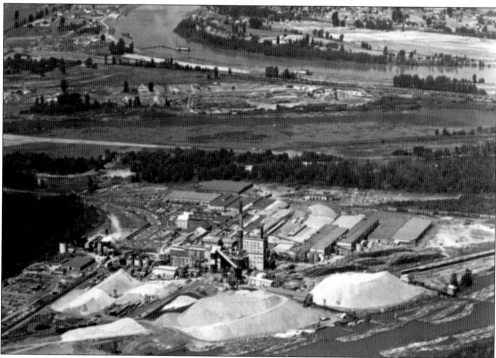

By the early 1960s, Longview Fibre had an independent supply of raw material, an international reputation, and a healthy revenue stream. In the center of this photograph is the log storage lagoon, built for the now demolished Long-Bell mills. Just above that is the former Exeter Mill, now a Weyerhaeuser subsidiary. Note the beginning of construction for Tennant Way in the upper-left corner. (Courtesy of Cowlitz County Historical Museum.)

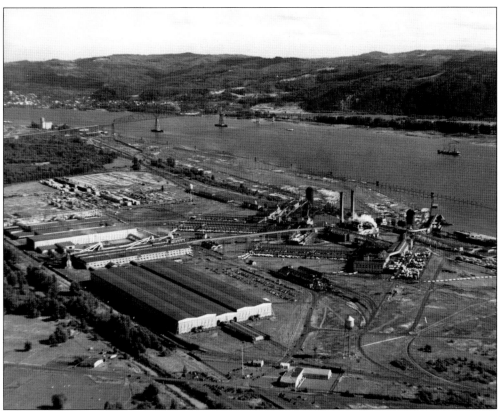

Like Long-Bell, wood waste led Weyerhaeuser officials to invest in pulp and paper. The first pulp mill, built by R.B. Wolf and Norman Kelly, opened during the depths of the Great Depression in 1932 and produced 170 tons of sulphite pulp a day. It is shown here adjacent to Mill No. 3 (double smoke stacks). Note the raceways in the river millpond and the grove of trees at upper left. (Courtesy of Cowlitz County Historical Museum.)

After operating at a small loss when first opened, the pulp mill became a profit leader for the company within two years. At first, it made bleached white sulphite pulp, which was shipped to a fine book paper manufacturer. During World War II, the federal government needed pure sulphite for smokeless nitrate explosives. Weyerhaeuser was able to respond with shipments like those pictured within six month of the attack on Pearl Harbor. (Courtesy of Cowlitz County Historical Museum.)

Weyerhaeuser created a joint venture with Wisconsin-based Rhinelander Paper Company to build R-W Paper in 1956. At the paper mills, the end products emerged on huge paper rolls, shown here. (Courtesy of Cowlitz County Historical Museum.)

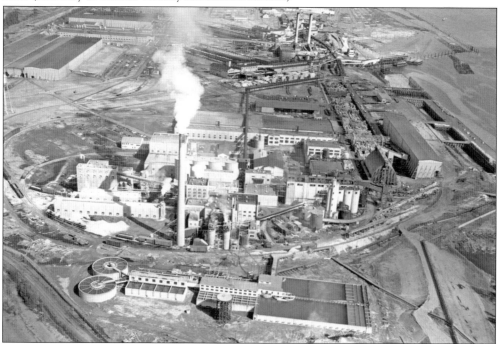

After World War II, Weyerhaeuser began construction on a new state-of-the-art facility, shown here, to produce kraft pulp that was capable of packaging liquids (like milk carton stock). In this 1960s photograph, a modern paper facility has dramatically changed the mill site. Mill No. 1 and the cargo dock remain (lower right), but the kraft plant dominates. Its wastewater treatment plant is in the foreground. R-W Paper is at upper left. (Courtesy of Cowlitz County Historical Museum.)

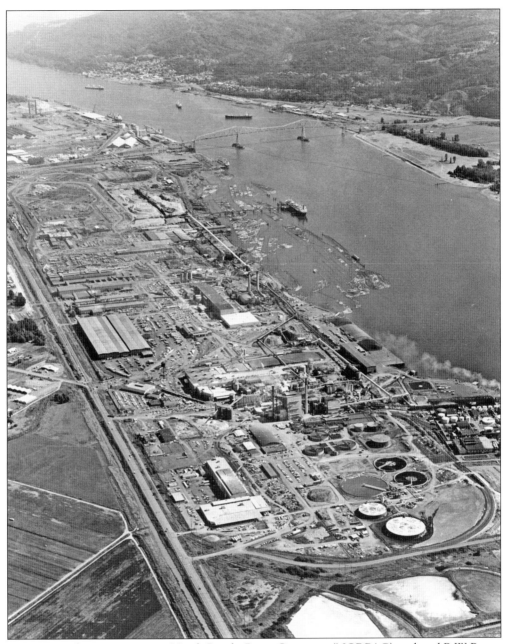

In 1976, another joint venture, North Pacific Paper Company (NORPAC) replaced R-W Paper, producing newsprint mainly from recycled paper. De-inking and the move away from chlorine bleach for pulp required more extensive wastewater treatment. At the north end near the bridge, the grove of trees became the new sorting yard and log export facility. A chemical plant now sits at the base of Mount Coffin. (Courtesy of Cowlitz County Historical Museum.)

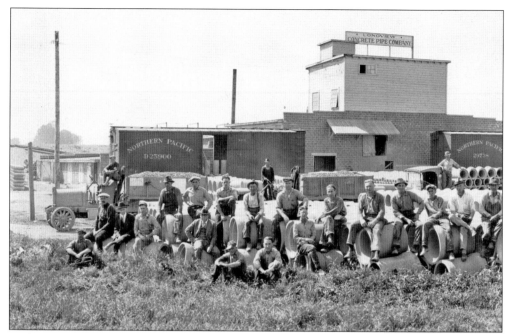

At least two construction-related businesses also took shape in the 1920s, with one supplying concrete and sewer pipes and the other supplying paints. Located near the railroad tracks along Third Avenue, Longview Concrete and Pipe Company started out as a Long-Bell subsidiary run by George Ruth (in center with suit and glasses). (Courtesy of Cowlitz County Historical Museum.)

Long-Bell's city planners built roads and sewer lines throughout the city, and the company relied on its subsidiary to supply needed concrete. (Courtesy of Cowlitz County Historical Museum.)

To promote more business for the company, Ruth became active in the Washington State Good Roads Coalition, responsible for successfully lobbying the state legislature on behalf of the community to fund major road construction. Here, city leaders celebrate the start of construction of Ocean Beach Highway in the mid-1930s. (Courtesy of Cowlitz County Historical Museum.)

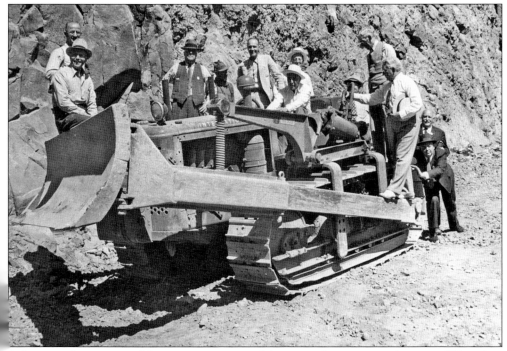

A few years later, many of these same activists celebrate another major road project: White Pass Highway. (Courtesy of Cowlitz County Historical Museum.)

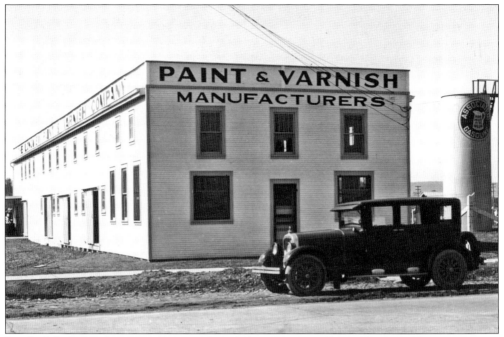

Run by R.L. Sailors, Longview Paint & Varnish Company manufactured many of the paint, stains, and varnish used in construction around Longview. (Courtesy of Longview Room, Longview Public Library.)

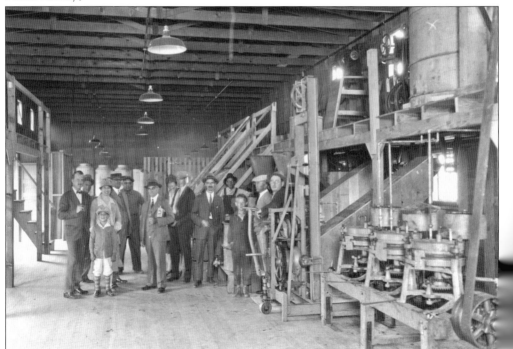

On opening day, the Sailors family hosted an open house. The youngsters are Bob (in front of his mother) and Jack (to the right). R.L. Sailors is just behind his wife, Elizabeth. C.R. Hammond i in the center. (Courtesy of Longview Room, Longview Public Library.)

Aluminum ingots, shown here, were among the most important items shipped from the Port of Longview. They were manufactured at the Reynolds Metals reduction plant, built just downriver from Weyerhaeuser. (Courtesy of Cowlitz County Historical Museum.)

During World War II, the federal government encouraged the development of aluminum production. Here, in the Pacific Northwest, the low cost of hydroelectricity attracted aluminum companies. Reynolds Metals selected Longview, and this plant opened in 1941. (Courtesy of Cowlitz County Historical Museum.)

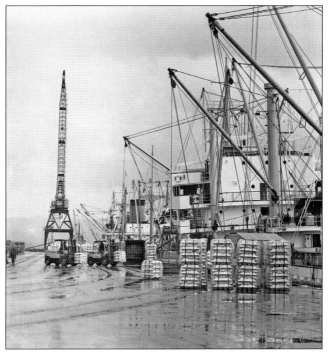

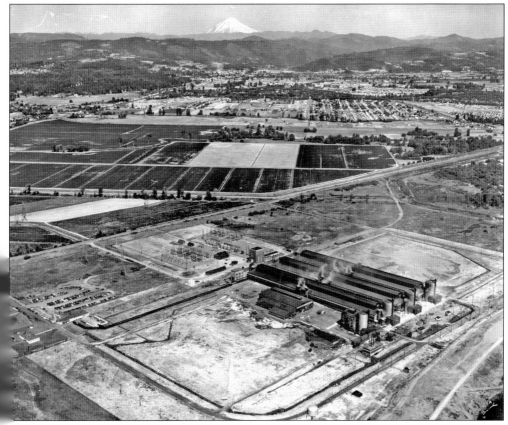

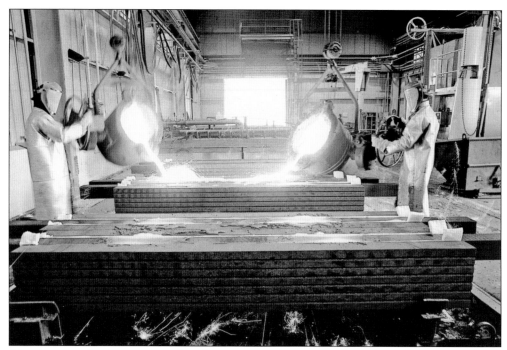

Aluminum production requires a lot of energy to produce ingots. Super-heated ore is poured into the potlines, out of which come the ingots. They were shipped elsewhere for further manufacturing. (Courtesy of Cowlitz County Historical Museum.)

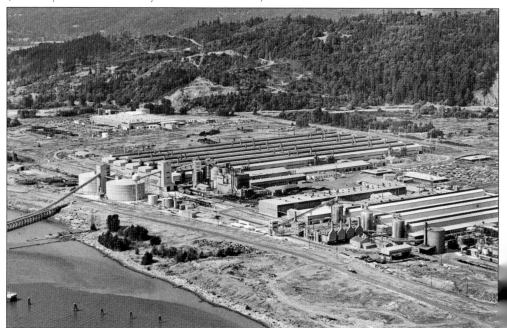

In 1966, the company more than doubled the facility and added a cable plant (just to the upper left of the new plant). Reynolds became the third largest employer in Cowlitz County. It finally closed in 2002 due to spiraling power costs and international competition. (Courtesy of Cowlitz County Historical Museum.)

Five

BUILDING A BUSY PORT
AND A TALL BRIDGE

Within a few years of Longview's founding, Wesley Vandercook planned to build a bridge across the Columbia River. He teamed up with W.D. Comer, a Seattle financier, and convinced Third District congressman Albert Johnson to sponsor the bill. Congressional victory over Portland interests came with a compromise giving details of the bridge height to a Cabinet-level committee that finally issued a permit to build in 1928. (Courtesy of Longview Room, Longview Public Library.)

68TH CONGRESS }
2D SESSION }
H. R. 11856

A BILL

Granting the consent of Congress to W. D. Comer and Wesley Vandercook to construct a bridge across the Columbia River between Longview, Washington, and Rainier, Oregon

By Mr. JOHNSON of Washington

JANUARY 22, 1925
Referred to the Committee on Interstate and Foreign Commerce and ordered to be printed

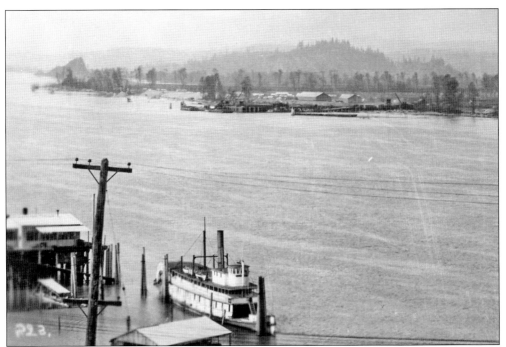

Vandercook's plan called for the bridge to be constructed next to the port voters had created when they approved the Port of Kelso in 1922. It finally located its facilities on the Columbia River near the foot of Oregon Way. The stern-wheeler is at a Rainier, Oregon, dock. Note that Mount Coffin and Mount Solo are in the background. (Courtesy of Longview Room, Longview Public Library.)

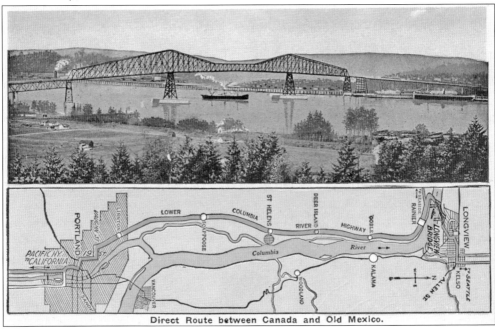

Direct Route between Canada and Old Mexico.

It was an important part of the plan to divert a lot of business into Longview. (Courtesy of Cowlitz County Historical Museum.)

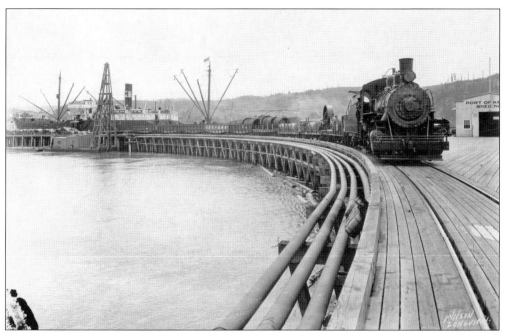

From the port, cargo was loaded on trains and switched over LP&N tracks to the mainline. (Courtesy of Cowlitz County Historical Museum.)

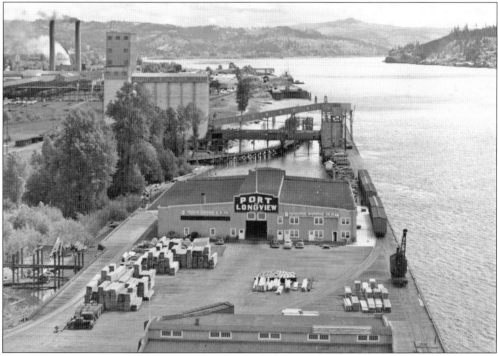

Its original name created confusion among shippers, and the elected commissioners changed it to the Port of Longview. This picture was taken during bridge construction. It became one of the top ports in tonnage on the West Coast. Note the Continental Grain Co. elevator in the center. (Courtesy of Cowlitz County Historical Museum.)

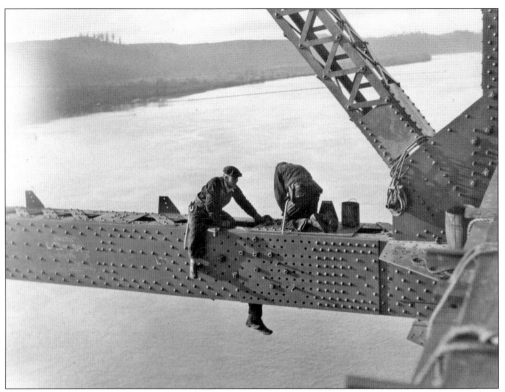

Longview-Rainier Bridge construction started once the federal permit was issued. It cost $5.8 million and was financed privately. The cantilever construction required riveters to work between 210 and 340 feet above the Columbia River. (Courtesy of Cowlitz County Historical Museum.)

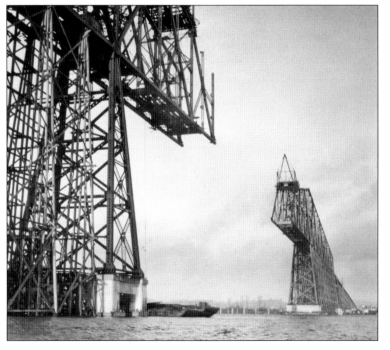

From below the bridge on the Weyerhaeuser side, the concrete piers are visible. (Courtesy of Cowlitz County Historical Museum.)

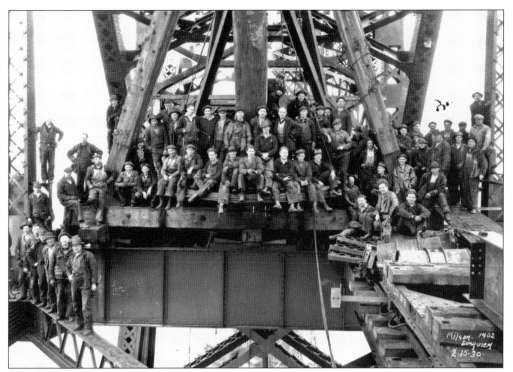

At 1.6 miles long with a center span of 1,200 feet, the bridge was the longest of its type in the United States at the time of construction. These construction jobs were greatly desired by workers in this 1930 photograph. (Courtesy of Longview Room, Longview Public Library.)

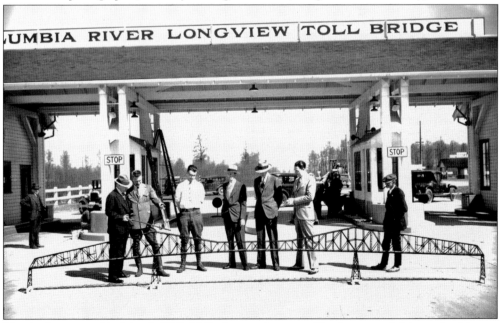

The bridge opened in March 1930. Tolls for crossing were 80¢ for car and driver, plus 15¢ per passenger and pedestrians. Motorcycles cost 35¢. (Courtesy of Longview Room, Longview Public Library.)

In 1947, the state of Washington purchased the bridge and collected tolls. On October 19, 1965, Washington governor Dan Evans burned the financing bonds for the Longview-Rainier Bridge, signifying that tolls were no longer needed. State highway commissioner George Zahn looked on. (Courtesy of Cowlitz County Historical Museum.)

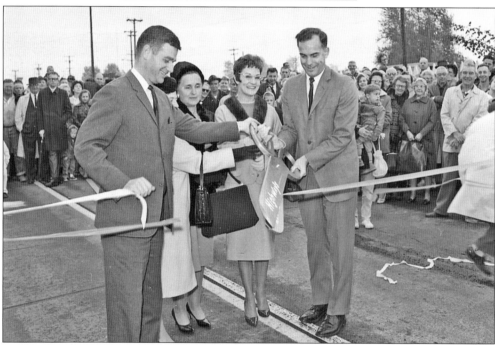

Cutting the ribbon to open the bridge to "toll-free" traffic were, from left to right, Oregon governor Mark Hatfield, US representative Julia Butler Hansen (Cathlamet), US representative Edith Green (Portland), Esther Keller, and Washington governor Dan Evans. Esther Keller, daughter of Wesley Vandercook, had cut the ribbon when the bridge originally opened in 1930. In 1980, the bridge was renamed the Lewis and Clark Bridge and was listed in the national Historic Register in 1982. (Courtesy of Cowlitz County Historical Museum.)

Six

CELEBRATING
OUR SUCCESSES

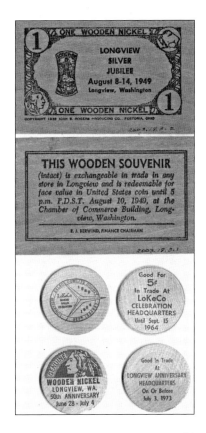

Wooden "nickels," like these, proved popular during the celebrations of the 1923 founding of Longview. The 1948 Vanport flood delayed the silver jubilee celebration by one year. The 40th anniversary was combined with the 75th Diamond Jubilee of Kelso at LoKeCo in 1964. The 50th was held in 1973. (Courtesy of Cowlitz County Historical Museum.)

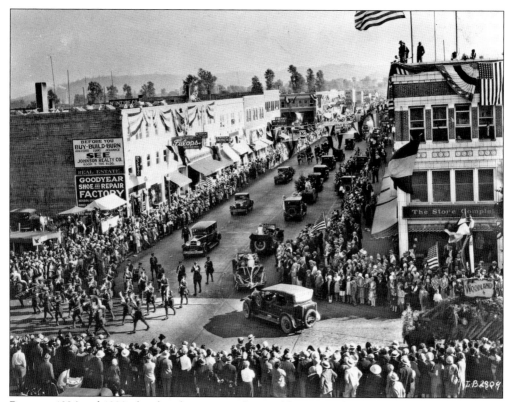

Between 1926 and 1928, the chamber organized annual Pageants of Progress, highlighting the rapid growth of Longview. The 1928 Pageant of Progress featured this Parade of the Northwest for the fifth anniversary of Longview. With 125 entries, the two-mile procession turned at Broadway and Commerce Avenue twice after a U-turn several blocks down on Commerce Avenue. It is still considered the parade to beat by modern organizers. (Courtesy of Longview Room, Longview Public Library.)

The 1928 celebration also included a beauty contest for Miss Longview. From left to right, Mildred Backeberg, Miss Longview Helen Drake, and Genevieve Craig are the "queen and her court." (Courtesy of Longview Room, Longview Public Library.)

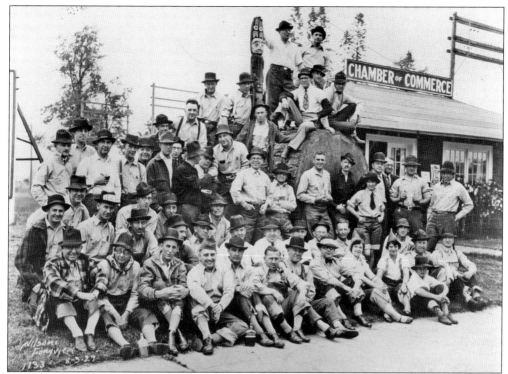

Indispensable to promoting the economic growth of Longview, the chamber of commerce sponsored many celebrations and parades, a tradition that continues under separate community organizations. Here, chamber members dress up for the Rolleo, an annual timber carnival held from 1929 into the 1930s. Note an uncharacteristically relaxed R.A. Long leaning against the log near the center. (Courtesy of Cowlitz County Historical Museum.)

Rolleo organizers were always willing to feature pretty girls in promoting the event. Here, they are standing in front of the Columbia Theater. (Courtesy of Longview Room, Longview Public Library.)

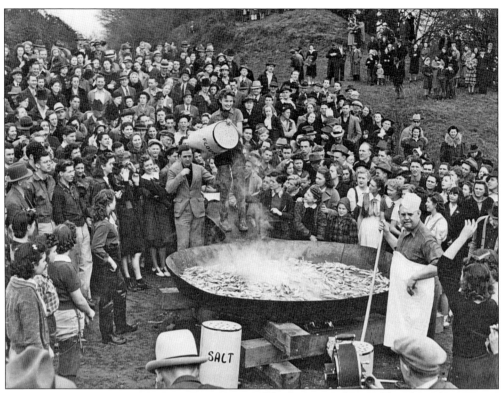

The Longview Junior Chamber of Commerce (JayCees) organized a 1940 event featuring a smelt fry on the "world's biggest frying pan" borrowed from Long Beach, Washington. Twins Evelyn and Ellen McGuinigle strapped on slabs of bacon to grease it. *Daily News* executives John M. McClelland Jr. (hand raised) and Carlton Moore (in apron) organized the event. For years, the JayCees sponsored the Fourth of July fireworks at Lake Sacajawea. (Courtesy of Cowlitz County Historical Museum.)

The Go Fourth Committee replaced LoKeCo with a multiday event in July at Lake Sacajawea that regularly attracts 20,000 annually for the timber carnival, an arts-and-crafts market, contests for youngsters, food vendors, live music, and the fireworks display. Sandbaggers Walt Naze and Jim Gray honored the late Al Mortellaro, a retired teacher who was the top button salesman for years. Button sales continue to help finance the fireworks. (Courtesy of the Sandbagger Collection, Cowlitz County Historical Museum.)

Seven

Mr. Long's Legacy: The People

Nearly 20,000 local residents gathered on the north field in front of R.A. Long High School across from Lake Sacajawea in September 1996 to welcome Pres. Bill Clinton, First Lady Hillary Clinton, Vice Pres. Al Gore, and Tipper Gore. These onlookers patiently awaited the arrival of the guests of honor at Longview's first-ever presidential campaign rally. (Courtesy of Cowlitz County Historical Museum.)

Longview's founders R.A. Long and S.M. Morris (second row, center) strongly encouraged the boys' Bible class of Longview Community Church. They are standing on the steps of Kessler School prior to the completion of the church's main sanctuary in the mid-1920s. (Courtesy of Cowlitz County Historical Museum.)

Newlyweds Joe and Ida Joe (Myklebust) Sanwick stand with their wedding party, which includes her sister Synaja (third from the left); her dad, K.T. Myklebust (standing next to the groom); and her brothers Truman (far right) and Kermit (seated second from the right). (Courtesy of Longview Room, Longview Public Library.)

The Longview Woman's Club met in various homes on the Old West Side until a clubhouse was built during the 1930s. This meeting at the home of John and Mollie Duett included Ruth Gebert (wife of Community Church pastor, standing second from the right), Eugenia Campbell (seated second from the left), and Katherine Vandercook (sitting on the lawn at far right). This house is now in the local historic register. (Courtesy of Longview Room, Longview Public Library.)

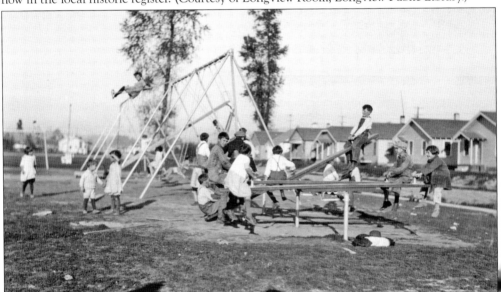

This playground at Highland Park was popular. Between Twenty-first and Twenty-second Avenues, this park was an example of the neighborhood parks concept championed by George Kessler, one of the nation's premier park designers and consultant at both R.A. Long's Longview Farms near Kansas City, Missouri, and here in Longview. This park now also includes baseball fields and tennis courts. It is known as Archie Anderson Park. (Courtesy of Cowlitz County Historical Museum.)

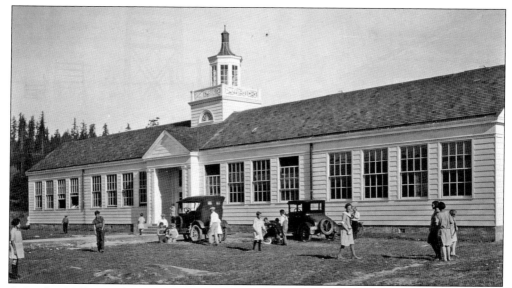

Columbia Valley Gardens Elementary School was one of Longview's earliest schools. More popularly known as CVG, it attracted students in 1926 from west Longview and nearby Columbia Heights. It was replaced in the 1970s, and the half-circle window below the cupola is on display in the school office. (Courtesy of Longview Room, Longview Public Library.)

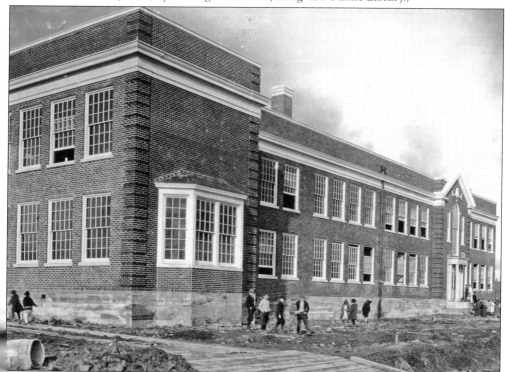

The other new elementary school was St. Helens. In 1926, it served students from the Highlands, Olympic, and part of the St. Helens Additions. It was replaced in the early 2000s, but large murals display photographs of the original school. (Courtesy of Longview Room, Longview Public Library.)

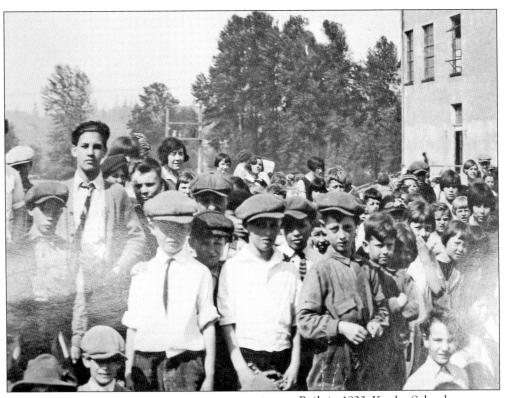

Built in 1923, Kessler School was the first school, serving students from the first to twelfth grades. (Courtesy of Longview Room, Longview Public Library.)

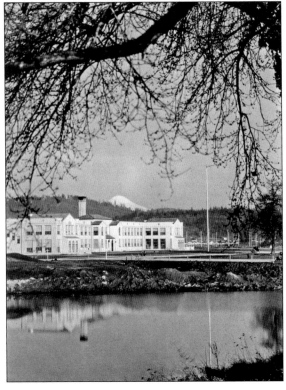

When CVG, St. Helens, and R.A. Long High School were built, Kessler became an elementary school. The years took their toll on Kessler School. In the 1970s, this building was replaced by a one-story structure without classroom walls, considered an innovative "model" school. (Courtesy of Longview Room, Longview Public Library.)

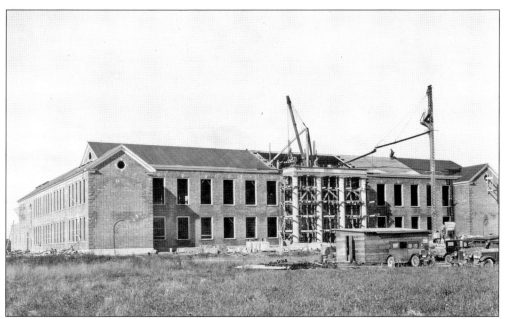

R.A. Long provided personal funds for a modern, inspiring high school for Longview. Its construction included imposing columns and a bell tower. The finished high school campus sat amidst landscaped lawns near Lake Sacajawea. (Courtesy of Cowlitz County Historical Museum.)

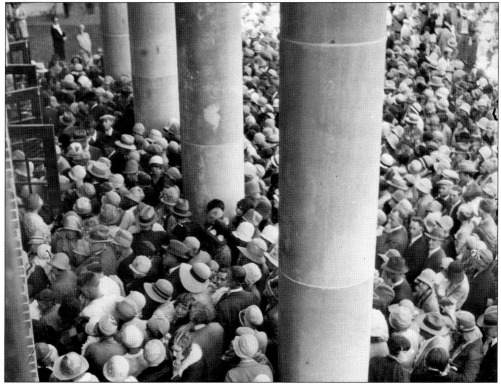

Nearly 5,000 residents attended the 1928 dedication ceremony and toured the new facility, named for its benefactor, R.A. Long. (Courtesy of Cowlitz County Historical Museum.)

John Hill coached the 1929 championship basketball team of the Longview-Kelso Intercity League. The Central Service team included "Swede" Auberg, Fred Johnson, Lawson Watkins, Earl Alexander, Dave Evards, Jim Johnson, Don Bremer, and Bud Watkins. (Courtesy of Longview Room, Longview Public Library.)

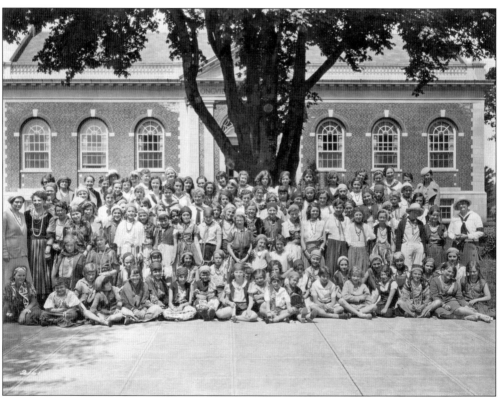

Having organized the Cowlitz County Campfire Board in 1933, Gay Quoidbach (standing second from the left) convened this meeting of participants outside the Longview Public Library. (Courtesy of Cowlitz County Historical Museum.)

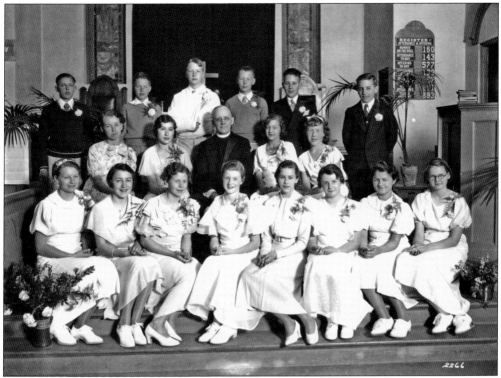

Reverend Knudson of Trinity Lutheran Church led this confirmation class of youngsters around 1935. Among the students were Burke Corman, Donovan Gorans, Dorene LaBeau, Ruth Carlson (Sailors), Doris Larson, Carolyn Soderlund, Dorothy Sowders, and Betty Lewis. (Courtesy of Longview Room, Longview Public Library.)

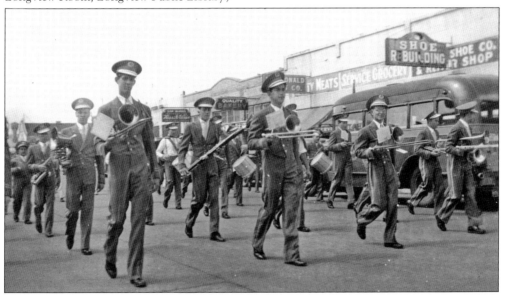

During the 1930s, the Longview Kiwanis Club sponsored a successful boys' band, shown here marching in a parade down Commerce Avenue; Harold Lutz is leading in the third row from the left. (Courtesy of Cowlitz County Historical Museum.)

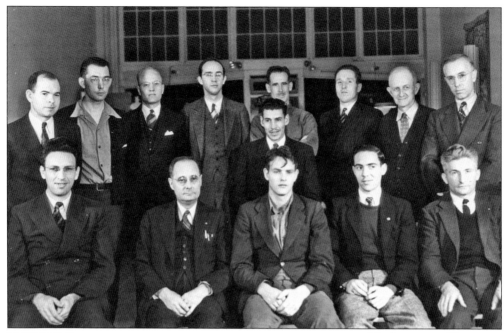

The Longview Gleemen sang for various events around the community during the 1930s. The group included Al Ross, Bob Cox, Rev. W.L. Kingon, H.C. Titus, Carl Stalhberg, Dr. M.R. Sathe, Roy Parsons, and Pete Sauressing. (Courtesy of Longview Room, Longview Public Library.)

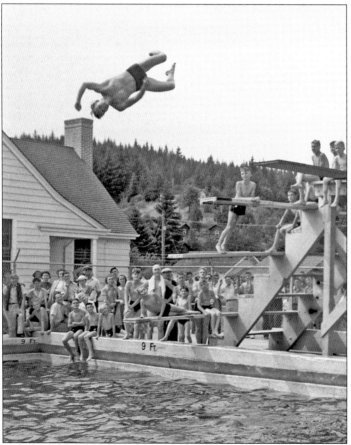

Longview youth enjoyed swimming at the area's only outdoor pool, Catlin Pool, which was built during the 1930s in West Kelso on land originally donated to the city of Kelso "for the benefit of youth." Today, it is the site of the popular Rotary Spray Park. (Courtesy of Cowlitz County Historical Museum.)

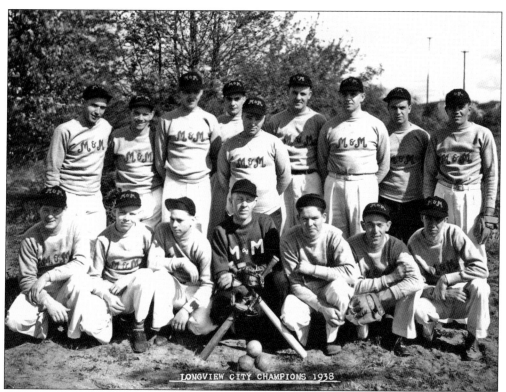

Softball was another popular pastime. The 1938 Longview City Champions included Pete Howe, George Newell, Dan Phillips, and Wilbur Kemper. (Courtesy of Longview Room, Longview Public Library.)

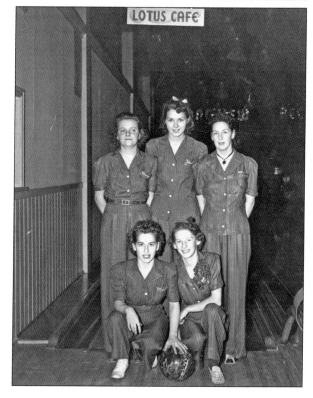

The Lotus Café women's team played at Martin Bowling Alley on Commerce Avenue, a popular location until 1946, when it burned down. The team included Margaret Lutnes, Juanita Rivers, Lorene (Pollard) Fisher, and Lois McGhee. (Courtesy of Cowlitz County Historical Museum.)

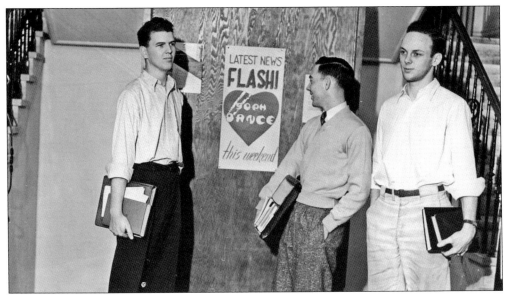

The community established Lower Columbia College in the 1930s as a two-year junior college for students who could not afford the more-expensive four-year colleges in other cities or for those who needed training for new jobs. Classes met in various locations before the main campus was established across Maple Street from the public library. Leland Stroope, Roy Parsons, and Harold Kerney took their classes in the basement of the public library. (Courtesy of Longview Room, Longview Public Library.)

Younger boys with a nautical interest joined Sea Scouts. Their training took place aboard the Monticello. This crew included Jack Zimmermann, Bill Staggs, Jim Ebbert, John Davidson, Carl George, Jim Jenkins, Allen Carl, John Klesch, Bob Quoidbach, Don Baker, and Jack Sathe. (Courtesy of Cowlitz County Historical Museum.)

The Longview Ski Club operated a lodge on Mount St. Helens and organized many trips through the years. Don and Allen Cripe (second and third from the left) were active members. (Courtesy of Cowlitz County Historical Museum.)

Helen Leonard's second-grade class attended CVG School from 1941 to 1942. (Courtesy of Cowlitz County Historical Museum.)

During World War II, the Finnish Congregational Mission Church on Columbia Heights honored these servicemen. (Courtesy of Cowlitz County Historical Museum.)

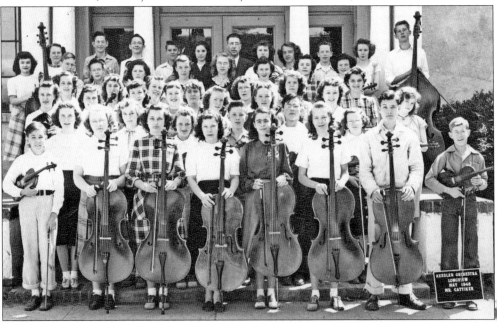

Kessler School's 1948 orchestra was led by maestro Irv Gattiker (back row, at center). He later taught at Lower Columbia College and organized the Southwest Washington Symphony. Members included Dorothy Boaglio, Ruth Walker, Dale Gunderson, Eugene White, Rex Wheeler, Belle Wright, Joan Mercer, Glenda Martin, Joan Hixson, Donna Mann, Arlene McKinney, and Dave Spencer. (Courtesy of Cowlitz County Historical Museum.)

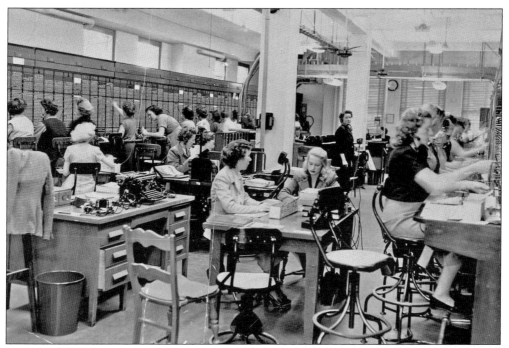

The switchboard operators of the Longview Telephone Company working Christmas Day 1950 included Mary Allis, Gladys Wilson, Joyce Halleck, Hazel West, and Gloria Lytel. (Courtesy of Cowlitz County Historical Museum.)

One active philanthropy involved support for the Children's Orthopedic Hospital in Seattle. The Lake Guild sponsored annual dances, and in 1954, Duke Ellington was the band director. (Courtesy of Cowlitz County Historical Museum.)

The Longview Community Church Temple Singers were well known for musical productions for the community, including patriotic songfests. Under conductor Neal Kirkpatrick (at the far right in the top row), they also presented Handel's *Messiah* for over 50 years, beginning in the early 1950s. Members included Dave Grocott, John Weber, Jack Boyd, Glen Potter, Howard McCausland, Ormal Tack, Chris Gerald, John Hill, Kay Kilborn, Ardith Joslin, Stella Logue, Ruby Anderson, Jeanne Kroll, and Ethel Kirkpatrick. The Rev. Ed Gebert, senior pastor, is at the far right in the fifth row. (Courtesy of the John Weber Estate.)

The Columbia Heights Assembly of God Church began in the late 1950s. Members originally met in a grange hall before building a small church of their own. The congregation is now one of the largest in the area. (Courtesy of Lloyd Smith.)

From left to right, Mark, Bill, and Dan Tucker enjoyed a visit in 1960 to the Longview Public Library, where they selected favorite books from one of the reading rooms. A photograph of their grandfather S.M. Morris is on the wall behind them. (Courtesy of Longview Room, Longview Public Library.)

During the 1965 "Youth in Government" Day, sponsored by the Longview Elks Club, Judy DeJarnatt is learning the duties of librarian from Longview Public Library's M. Josephine Moore. (Courtesy of Longview Room, Longview Public Library.)

The Southwest Washington Symphony organized in 1966 under the direction of Irv Gattiker. This is from the 1968–1969 season, taken in the R.A. Long High School Auditorium; those pictured include concertmaster Bill Watson, Carl Spellman, Nancy Watson, Henry Futrell, Dennis Weber,

Longtime members of the Longview '23 Club were honored at the 1966 annual dinner held at the Longview Community Church. They are, from left to right, (sitting) John Null, Gay Quoidbach, and C.C. Tibbets; (standing) the Rev. Ed Gebert, C.E. Hadley, John M. McClelland, John Hill, and Roy Morse. (Courtesy of Cowlitz County Historical Museum.)

Tom and Doris Hall, Dolphine Van Zanten (Mack), Dr. Neal Kirkpatrick, Dr. Marion Clark, Linda Aho (Monohan), Dr. D.D. Winebrenner, R.P. Wollenberg, and Deana Enbusk (Martinson). (Courtesy of Linda Monahan.)

The only time Longview voters have approved a city bond issue, they agreed to expand the public library in 1966. In this Jan Fardell photograph, Betty and Gene McNalley study the model of the proposal when it was on display at the county fair. (Courtesy of Longview Room, Longview Public Library.)

Many local labor unions sponsored little league baseball teams. The AWPPW Local No. 633's team played in the Central League headquartered at Highland Park. In this 1960s photograph, team members included Wayne Nichols, Keith Weber, Steve Harmon, Chuck Gregory, Robbie Fournier, and mascot Cathy Jo Meyers. Her dad Marshall was the team manager. (Courtesy of Cowlitz County Historical Museum.)

The wooden Hemlock Street Footbridge collapsed during the 1968 Fourth of July festivities at Lake Sacajawea. Fortunately, there were no injuries. A new all-aluminum bridge with a dramatic arch was donated by Reynolds Metals and still serves residents today. (Courtesy of Cowlitz County Historical Museum and the *Daily News*.)

To replace the Y Camp Mess Hall, destroyed by a fallen tree in the early 1960s, Longview community members organized a task force to build this new A-frame Main Lodge. It sat on piling directly over Margaret Creek with large windows overlooking Spirit Lake and Mount St. Helens. (Courtesy of Cowlitz County Historical Museum.)

The Longview YMCA operated a summer camp at Spirit Lake Camp since the 1930s. In 1968, the camp director was future county commissioner Bill Lehning, shown here at far left with his staff in front of some of the cabins. (Courtesy of Cowlitz County Historical Museum.)

Canoeing was just one of the popular aquatics activities at the Y Camp. Some campers jumped into the frigid water first thing every morning. Others swam various distances across the lake and went rowing and water-skiing. (Courtesy of Cowlitz County Historical Museum.)

The spiritual and character-building aspects of Y Camp were addressed by earning "Rags," a different one for each year, depending on actions and knowledge acquired. Camper Bob Larson shows his second rag. (Photograph courtesy of Cowlitz County Historical Museum.)

Y Camp staff is shown in 1977, just a few years before the eruption of Mount St. Helens destroyed the camp, along with several private resorts, Forest Service campgrounds, a Portland Y Camp, and camps for both Boy and Girl Scouts. Camp director Bob Rosi is standing at the far right in the top row, assistant director Rick Anderson with glasses is at center in the top row, and veteran camp storyteller Tommy Jabusch is seated at center of the bottom row. Jane Rosi is just to the right of Jabusch. (Courtesy of Cowlitz County Historical Museum.)

Western Little League teams play at John Null Park and begin tournament play with the Pledge of Allegiance. Now affiliated with the Babe Ruth League, Longview teams play host to the Babe Ruth World Series at the LCC ball field. (Courtesy of the Jan Fardell Collection, Cowlitz County Historical Museum.)

Mayor Dennis Weber passes the torch to the next leg of the torch relay as it came through Longview on the way to the 1984 Los Angeles Olympics, the first time Longview has been so honored. (Courtesy of Wendell Kirkpatrick.)

Eight

COPING WITH DISASTERS

Just as enthusiasm for all the building going on in Longview was reaching a feverish pitch, Mother Nature reminded everyone of her awesome and unpredictable power. In early January 1923, the Cowlitz River was swollen. A logjam got caught against the wooden piers and swept away the "new" drawbridge on Allen Street. (It had replaced one swept away less than 20 years earlier.) This was one of a few autos recovered in its aftermath. (Courtesy of Cowlitz County Historical Museum.)

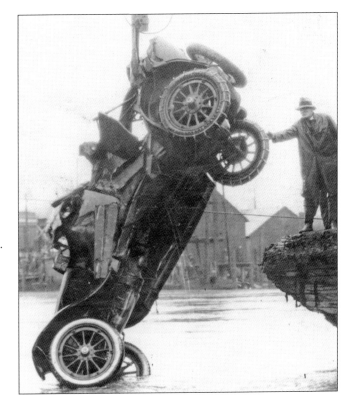

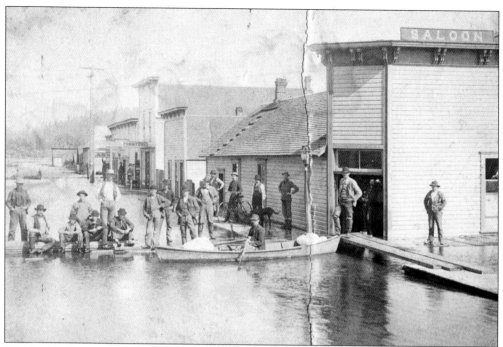

The bridge disaster of 1923 was not the first to hit this area. In the 19th century, floods were a frequent challenge for settlers, as Darby Huntington found out at Monticello in the 1860s. Here is a rare photograph of Kelso during the flood of 1894. (Courtesy of Cowlitz County Historical Museum.)

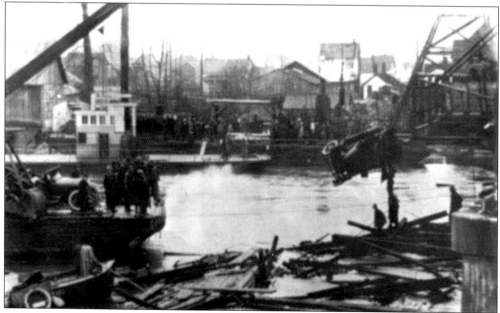

There were casualties from the 1923 Allen Street Bridge disaster. The family of Lloyd Huntington drowned. The Huntington car (see previous page) is on the barge in this photograph. The L.A. Darr car is being hoisted out. But as with many disasters, a lot of onlookers lined the shores to watch. (Courtesy of Cowlitz County Historical Museum.)

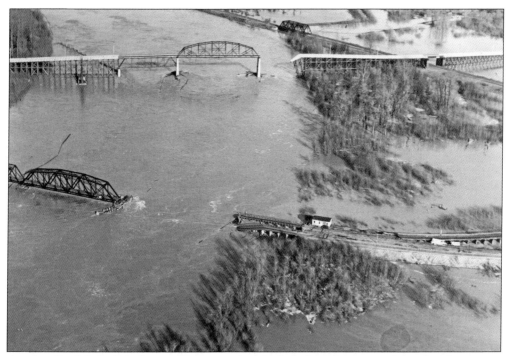

Another flood dashed the hopes of Longview founder R.A. Long for twice-a-day railroad passenger service there. Not only did the flood of 1933 wash out rail connections north of Castle Rock but also this railroad bridge (lower) connecting with the main line at "Longview Junction." But with the Great Depression, only this one was rebuilt. Passenger service reverted to Kelso completely, as is the case today under Amtrak. (Courtesy of Cowlitz County Historical Museum.)

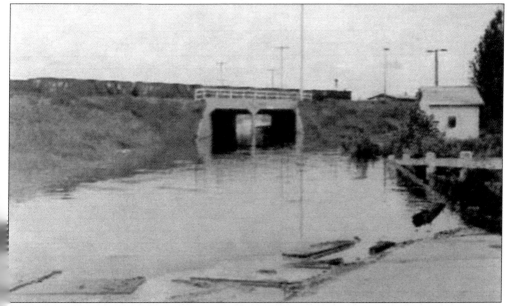

Before Tennant Way was built, California Way included a narrow tunnel under the LP&N switching yard. During extreme storms, the tunnel invariably flooded, much to the consternation of mothers and the delight of teens. (Courtesy of Longview Room, Longview Public Library.)

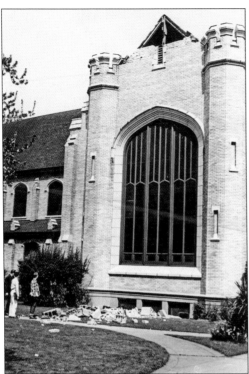

Longview Community Church suffered damage from the October 1949 earthquake that unfortunately took the life of a student at Castle Rock High School. There was no other loss of life from this earthquake, although many downtown Longview buildings lost facade features. (Courtesy of Cowlitz County Historical Museum.)

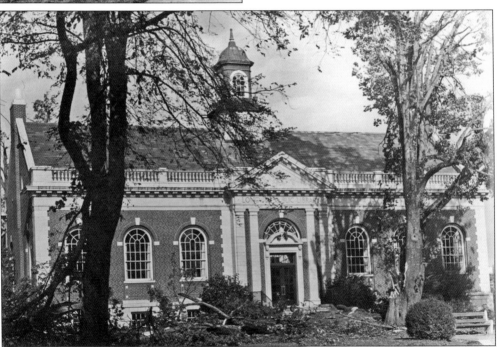

One memorable disaster occurred on October 12, 1962. Known as the Columbus Day Storm, winds blew at hurricane velocity, ripping roofs asunder and sweeping debris across the landscape. Especially hard hit were tall trees, like the grand chestnut in front of the Longview Public Library. (Courtesy of Longview Room, Longview Public Library.)

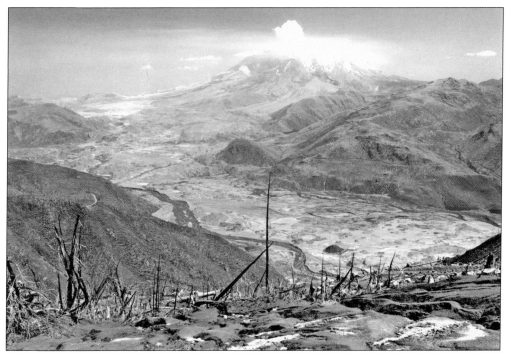

The eruption of Mount St. Helens on May 18, 1980, collapsed the north face of the mountain into the Spirit Lake basin, raising it over 300 feet. It also blocked the Upper Toutle River valley, a major tributary of the Lower Cowlitz River, and destroyed a lot of Weyerhaeuser's St. Helens Tree Farm. When winds shifted, the ash fell on Longview. Compare the damage here with the view on page 67. (Courtesy of Cowlitz County Historical Museum.)

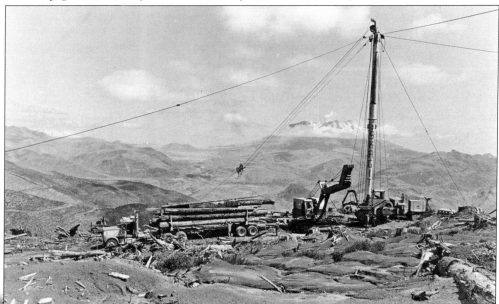

Salvage logging operations throughout Weyerhaeuser's St. Helens Tree Farm took place as soon as conditions were safe enough to resume logging. But, the abrasive qualities of the ash wore out saws and equipment rapidly. (Courtesy of Cowlitz County Historical Museum.)

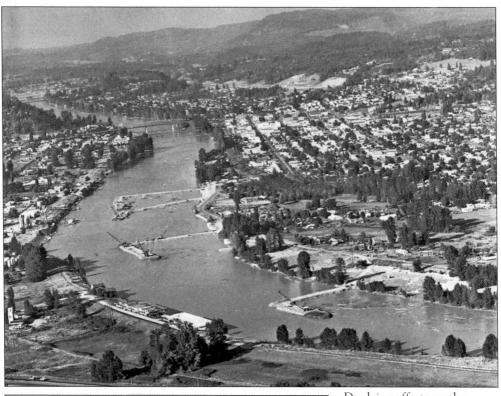

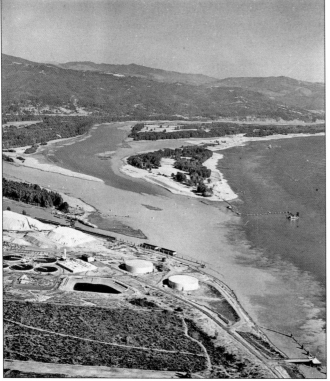

Dredging efforts on the Cowlitz River were a major part of a $1 billion cleanup program approved by Congress within months of the eruption. The dredge spoils being scooped up in this photograph were eventually placed in a nearby lowlands and formed the basis for a new 18-hole golf course. (Courtesy of Cowlitz County Historical Museum.)

So much volcanic sediment flowed down the Toutle and Cowlitz Rivers that shipping lanes on the Columbia River were blocked for weeks until the US Army Corps of Engineers could complete dredging operations. (Courtesy of Cowlitz County Historical Museum.)

BIBLIOGRAPHY

Alley, B.F. and J.P. Munro-Fraser. *History of Clarke County, Washington Territory.* Portland, OR: Washington Publishing Co., 1885.

Cowlitz County Historical Quarterly. Vol. 45, No. 1. Kelso, WA: Cowlitz County Historical Society, 2003.

Cavens, Travis and David Freece. *Cowlitz County: Then and Now.* Kelso, WA: Cowlitz County Historical Society, 2006.

Jones, Alden H. *From Jamestown to Coffin Rock: History of Weyerhaeuser Operations in Southwest Washington.* Tacoma, WA: Weyerhaeuser Company, 1974.

Log of Long-Bell. Kansas City, MO: Long-Bell Lumber Company, 1926.

McClelland, John M. Jr. *Cowlitz Corridor.* Longview, WA: Longview Publishing Company, 1952.

McClelland, John M. Jr. *R.A. Long's Planned City: The Story of Longview, 75th Anniversary Edition.* Longview, WA: Westmedia, 1998.

Ott, Ruth and Dorothy York (ed.). *History of Cowlitz County.* WA: Cowlitz County Historical Society, 1983.

Our Town at 75: Reflections on R.A. Long's Planned City, 1923–1998. Longview, WA: *Daily News*, 1998.

Potter, Col. Chas. L., *Kalama Quadrangle US Army Tactical Map.* Washington Barracks, DC: US Army Corps of Engineers, 1919.

Rubin, Rick. *Naked Against the Rain: People of the Lower Columbia River 1770–1830.* Portland, OR: Far Shore Press, 1999.

Rushford, Brett H. *Emergence of Longview, Washington: Indians, Farmers, and Industrialists on the Cowlitz-Columbia Flood Plain.* Logan, UT: Utah State University, 1998.

Summers, Camilla G. *Go to the Cowlitz, Peter Crawford.* Longview, WA: Speedy Litho, 1978.

Urrutia, Virginia. *They Came to Six Rivers.* Kelso, WA: Cowlitz County Historical Society, 1998.

Weber, Dennis P. "The Name 'Washington:' Common Sense or Stroke of Genius?" *Columbia.* Tacoma, WA: Washington State Historical Society, Fall 2003.

Weber, Dennis P. "Pioneer Rebellion North of the Columbia." *Cowlitz Historical Quarterly*, No. 2. Kelso, WA: Cowlitz County Historical Museum, 2002.

Wilson, Roy I. *History of the Cowlitz Indian Tribe.* Cowlitz Tribal Council, unpublished, 1992.

INDEX

DISCOVER THOUSANDS OF LOCAL HISTORY BOOKS FEATURING MILLIONS OF VINTAGE IMAGES

Arcadia Publishing, the leading local history publisher in the United States, is committed to making history accessible and meaningful through publishing books that celebrate and preserve the heritage of America's people and places.

Find more books like this at
www.arcadiapublishing.com

Search for your hometown history, your old stomping grounds, and even your favorite sports team.

Consistent with our mission to preserve history on a local level, this book was printed in South Carolina on American-made paper and manufactured entirely in the United States. Products carrying the accredited Forest Stewardship Council (FSC) label are printed on 100 percent FSC-certified paper.

MADE IN THE USA